Dirt Cheap Photo Guide to Grand Teton National Park

Jeff R. Clow

Copyright Jeff R. Clow 2011
ISBN 978-1-4581-5679-2
Printed version published by Memory Book Studio
www.memorybookstudio.com

Table of Content

Chapter One - The Photographer's Quest

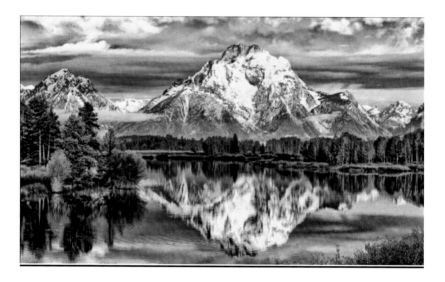

Oxbow Bend. The Snake River Overlook. Moulton Barn. Legendary landscape locations in Grand Teton National Park that have beckoned photographers for decades. You've heard of them and you've seen countless shots from each of these spots, but do you know what's the best time to visit them during the day? Do you know the alternative angles that produce images that aren't the standard postcard view of the place?

And what about off the beaten path locations such as Buffalo Fork Ridge or Hedrick Pond Overlook? Have you heard of them? Probably not. They are accessible but without a knowledge of the back roads that cross the main highways, they don't get many visitors. They are equally impressive when compared to their more famous brethren in the park, but they don't show up on any maps. Do you know how to get to them - and is it safe to do so in a rental car?

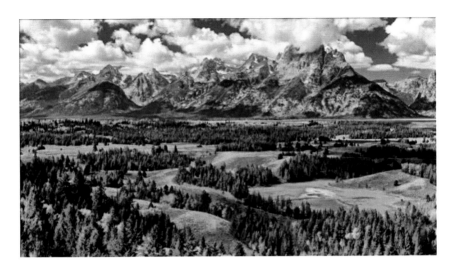

That's where this inexpensive photo guide comes in - a written recap of the area in and around Jackson Hole, Wyoming that is focused on one thing. Photography. Not on where to stay or where to eat, but where to stand and when to do so.

I've been visiting the area for ten years and have been leading photo tours for the last three years to this landscape and nature photographer's paradise. And the first time I visited Jackson Hole and Grand Teton National Park, I missed out on dozens of different photo spots because I didn't know who to ask and I didn't know my way around the area.

I remember asking myself repeatedly - is this dirt road on my left private or public? Is the fence in front of the barn a barrier to me or to the bison and can I go around it without getting in trouble? And then I would visit some of the well known galleries in the town of Jackson, Wyoming and see a shot that I'd love to take, but I had no idea how to get there. Or I would have two days to take photos and I wasn't sure where to devote that first hour just before sunrise. Should I go to the barns or go to Oxbow? Thus, my first couple of visits to the area were equal parts reward and frustration.

But I was lucky. My step-daughter and her husband had just moved to the area and so my wife and I had a reason to visit. We loved the place and we could visit without needing to shell out hundreds for hotel rooms. And so I began my quest - my quest to find the best places in Jackson Hole for a photographer and my quest to understand when the light was going to be best at each of those locations.

And slowly, but surely, I began running into local photographers at some of the sites. I would strike up a conversation and ask what other spots they would recommend. Some were very willing to tell me and others acted like that I was asking them for the secret formula for a well known soft drink. They clammed up and basically gave me the cold shoulder. But after years of asking and exploring every back road I could find in the park, I began to get a real sense of the place. A sense of the "vibe" that you sometimes hear the locals talk about.

Fast forward to today. Many of those photos this self taught landscape and wildlife photographer took ended up catching the eye of editors at Getty Stock Images. They are now being used by companies all over the world in advertising and promotion campaigns. My own portfolio on Flickr.com has been visited over four million times and I've won lots of accolades. But the truth is that so much of good photography is simply based on one thing - and one thing only.

If you want to get better and better at photography - **you've got to stand in front of better things**.

Then things like light and composition and depth of field come into play. But - other than repeated visits to the area - how does a photographer on a quest figure out where and how to spend their precious time when they visit Grand Teton National Park? Do they grab a rental car and head north on Highway 89 out of Jackson? Well, that will work. Some of the most iconic locations are literally on the main road. But the problem becomes one of prioritizing and knowledge - or lack thereof. Oxbow Bend is easy to find, but if you wait until noon to hit this magical

spot, the famous mirror reflection of Mount Moran in the bend of the river is likely going to be gone.

Why? Simple weather patterns and the fact that on most days the winds pick up after 9:00 a.m. just enough to ripple the water and disrupt the reflection. Will you still get a decent shot of the place? Sure. But the iconic shot that you've seen in all the guidebooks may be out of your grasp.

Thus, you need a guide. You can employ one of the many local photographers who offer guided tours of the area for visiting photographers. I personally know a couple of people who do a terrific job and will take you exactly where you need to go and when. The downside? They are expensive - usually in the range of $500 to $900 per day per person. But you'll get the shots that you've always wanted.

Or you could join a photo tour or photo workshop focused on the area. During the spring, summer and fall months there are workshops almost every weekend. Many led by well known photographers whose work has appeared in many national publications. My small company - Dirt Cheap Photo Tours - offers inexpensive guided tours for small groups several times a year. But once again, there are some limitations. You have to be in the area when the workshop or tour is held. And you have to travel with six to ten other people - a fun experience but maybe not what you want to do if you're visiting the area with your family and the photography part of your trip is only part of the overall experience.

Or you could use this book as your personal guide to the area that will allow you to travel at your own pace and visit the sites that resonate with you personally.

As my knowledge of the Jackson Hole area became well known, I started getting emails from strangers almost every week. They would invariably begin like this:

"Hi, Jeff. I saw your photos of Grand Teton National Park online and I'm visiting the area next month and was hoping you could give me some

pointers. I'm going to be traveling with my kids and I only will be in Jackson Hole for a couple of days because we're spending most of our time in Yellowstone. Can you tell me where I should devote the morning hours to during my visit?"

Over the course of the last several years, I've received countless requests similar to this and I've tried my best to be responsive. But the harsh fact is that there is too much too see - and photograph - in the park to be able to give a definitive answer. If you're a landscape photographer, then there are a half dozen places that are "must visit" in my opinion.

But if you also want to have the best chance to encounter - and photograph - wildlife, then there are other places that are better to visit if time is of the essence. You won't get a killer landscape photo at these locales, but you'll be much more likely to run into a deer or a moose or sometimes a bear.

So, let's say you are one of those who would trade a sunrise at a landscape location for a chance to photograph a moose. Then the place you need to be standing is on the shoreline of one of the three ponds that are adjacent to the dirt road on Moose-Wilson Road.

Moose-Wilson Road

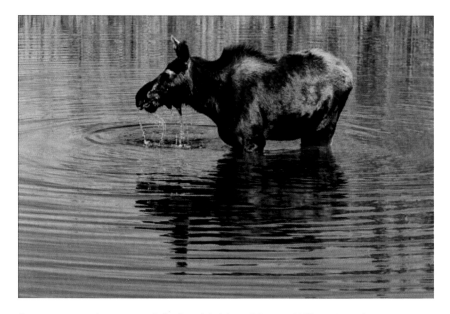

Contrary to what you might be thinking, Moose-Wilson Road was not named thusly because you see moose often on this stretch of roadway. It was named this because it starts in the town of Moose, Wyoming and runs southwest until it ends in the town of Wilson, Wyoming.

Throughout this book you'll see many places that will become your own personal target list as you prepare for your visit to the area. Each time you come across one of these that you want to add to your "must see" sites - you'll want to make a note of it and develop your own shooting list for each day you are at the park. You can then make adjustments if the weather changes on you or if you encounter unexpected wildlife where you least expect it.

Now, back to our quest for a wildlife shot during a brief stay in the park. This - and all subsequent directions - assumes you are staying overnight in the town of Jackson, Wyoming. If you are staying inside the park or nearby elsewhere, you'll still be able to find each spot because I'll use well known roads as directional start points.

First, determine when sunrise is going to occur for the day you plan to head out. In the summer months, this may be an hour or two earlier than in the spring or fall. I would recommend using one of the many well known apps that show sunrise and sunset times for any location if you have a smart phone. If you don't, check the local forecast on the television the night before.

Leaving your hotel in downtown Jackson at least 45 minutes prior to sunrise - head north on Highway 89 out of town. At the Moose junction, turn left (west) and drive across the bridge that spans the Snake River. As you cross the bridge, look to your right and left near the banks of the river - often moose congregate here to feed on the willows that line the banks.

And of course, during your drive to this location, watch for groupings of vehicles pulled off the road. Many times this will be your first indication that there are wildlife close by - and you should slow down or stop and check it out.

After crossing the bridge and immediately past the visitors center, you'll see a road veering left that is marked "Moose-Wilson Road". Take that road - which is paved at this point - and begin driving south/southwest. On your right and left immediately after you turn on to the road are stands of aspen trees. Watch closely because often you'll catch a deer or an elk in the early morning hours walking through the trees here.

As you continue south/southwest, you'll come to a paved overlook on your left side. Park here and look down and you'll see a meadow that is often frequented in the early morning by elk and moose and the occasional bear. Your best course of action is to stand on the ridge for several moments quietly and listen to the sounds of nature and often you'll hear a rustle or see a movement that indicates wildlife.

After you've worked this area, continue driving south/southwest and the road will narrow. On your left will be a series of shallow ponds that

are home to moose, bear, owls and deer. Drive slowly and you'll see a couple of small turnouts where a few cars can park. If there is wildlife present, there will likely be others who've already spotted them and have pulled off the road. Sometimes, if there's a major event - like a bear spotting - there may even be a park ranger or two present. Pull your vehicle off the road and grab your tripod and camera and walk towards the activity.

Tripod? Yes, if you have one you'll want to carry it. I know - it's a heavy burden and it slows you down, but if you want crisp nature and wildlife shots, you need to use it. Vibration reduction and image stabilization lenses do work, but the majority of great wildlife shots you'll ever take will be with a tripod or monopod.

If there is not activity, don't despair. You may be in luck and be the first in the area. Walk slowly toward the shore of one of the small ponds and listen intently. If you're alone, put all your senses on full alert. There have been several times in this area when I almost walked on top of a moose before I saw it. And remember that noise can startle a wild animal and make them bolt, so tread lightly.

The reason that there's a good chance you'll find wildlife here is because there is vegetation on the bottom of the pond that moose find irresistible to eat. There's also an abundance of willow trees along the road that are also sought out by moose.

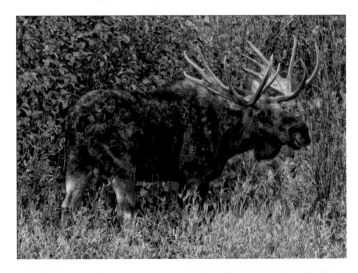

If you detect a moose, keep your distance. Park rangers have for years told me that a moose is much more dangerous than almost any other wild animal. They are prickly and may charge you if they think you are invading their space - so give them plenty of breathing room. That said, don't be too scared as they are fairly docile if you stay far enough way.

For this particular area, I'd recommend using a zoom lens that is at least a 200mm or longer. Ideally a 300mm - perhaps with a teleconverter - will get you a good shot of the animal at a comfortable distance. You'll need to set your ISO up high - probably in the 800 to 1200 range - to keep enough light on your subject during the early morning moments before and just after dawn. If you're new to photography, just set your camera on the program mode and it will figure out ISO and shutter speed for you.

The most important thing to do is to use a tripod or a monopod and aim your lens so that your central focus point is the moose's eye - or head. And remember, digital film is cheap - so take lots of shots at different exposures so you'll be sure to have a few keepers after all is said and done.

Once you have gotten your shots at the ponds, continue your drive south/southwest. Approximately a half mile south after the ponds you'll come across a series of willow trees alongside the left hand side of the road with water at their base. Not really ponds, per se - but water that keeps the willow growing well throughout the summer droughts. To the east you'll see a meadow beyond the willow trees. And as you clear the area, on your left will be a dirt road. If you haven't seen anything up to this point, you may want to turn on to the dirt road and park on the area to the right and get out of your vehicle and do a search of the meadow to your north.

Here's a shot I took of the meadow with the willow trees behind the bull moose. If you look closely, you can see that he's standing guard over his doe who is laying in the grass on the lower right hand side of the shot. Only her ears are sticking out of the grass.

9

One of the things about this open space is that it gives you a chance to see the wildlife in the context of the larger landscape around them. So don't forget to shoot some frames with a wider angle lens that will help others "see" what you saw when you had your encounter.

After you leave this area, you can continue south as the paved road turns into dirt. You'll be surrounded on both sides by dense forest, but in the early morning you're apt to come across elk or deer in the forest. They are tough to photograph because there is so much dense brush,

but if you're lucky, you may spot a clearing along the way that will give you an open shot. This land was once the private reserve of the Rockefeller family, who deeded it to the Park Service several years ago.

Or you can turn around at this juncture since you have the room to do so and head back north in search of another stellar site that is less than thirty minutes away and will have perfect light for its location as you arrive there. The location? The magical Schwabacher Landing.

Chapter Two - Schwabacher Landing - Upper, Lower and the Beaver Pond

Schwabacher Landing - if you're a fan of landscape images, you've surely seen hundreds of images taken at this iconic location. It probably - along with Oxbow Bend and Moulton Barn - is the most photographed site in Grand Teton National Park. Yet, many newcomers to the area never venture down the dirt road that leads you to the multitude of photo opportunities that are present along the branch of the Snake River that is accessible via the landing.

At this point, we should set our bearings. The vast majority of great locations in Grand Teton National Park are off of only three main roads - Hwy 89 that runs north from Jackson to the Moran junction turn, and then veers left (west) and ultimately leads to the southern entrance to Yellowstone National Park.

The second road that you'll need to become familiar with is Teton Park Road that runs primarily north and south at the base of the Tetons and is mostly parallel with Highway 89, although much further west. You can access it by turning left at the Moose Junction turn and driving past the visitor's center headed west/northwest.

The third road is Highway 287 that branches off headed east from the Moran Junction. This will lead you out of the park, but offers some spectacular panoramic views that we'll review later in this book.

Headed north on Hwy 89 out of downtown Jackson, you'll pass by the airport and then Moose Junction - both on your left. You'll continue north past the Blacktail Ponds Overlook and the Glacier View turnout. You'll probably want to stop a half dozen times during your journey because of the magnificent scenes all around you, but stay focused and continue northward.

Approximately a quarter mile past Glacier View, watch for a dirt road on your left with a small sign that says "Schwabacher Landing". It is such a small sign that it is quite easy to miss.

The road is rutted, but you can safely take a rental car down it if you drive slowly. There are actually three distinct stops that you'll want to make, but initially drive the mile or so until you come to the gravel parking lot at the end of the road. You'll know you have made it because you'll see toilet facilities erected by the Park Service at the lot. And a word to the wise - never pass a toilet without taking advantage of it, since they are few and far between within the park.

As you pull into the lot, before you will be a spectacular scene - a slow moving branch of the Snake River and the Teton mountain range hovering over the river. Since you're getting here early - let's call it an hour or so after sunrise - the winds should be quiet and you should see a mirror reflection of the Tetons in the water.

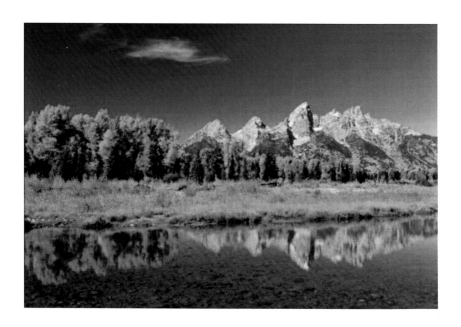

The scene in front of you is breathtaking, and you'll want to take out your tripod and wide angle lens to capture the panoramic view. I would recommend a lens in the 16mm to 28mm range. Running alongside the eastern side of the river is a dirt path that you'll want to use later on to get to the beaver pond to the north.

But first, you'll want to work the scene before you - and if you have mobility issues, you can literally get out of the car and shoot from the parking lot. But, if you're able, then you'll want to head down to the bank of the river. You'll need to experiment with lots of different angles - shooting from the top extension of your tripod, shooting from a level at your knees and then ultimately as low as you can get against the ground. The reflection changes dramatically as you take these different shots and the lower you get, the more of the foreground interest you can get. Foreground interest is the stuff that will give your photo depth - the flowers on the bank, the rocks in the river. Since you are using a tripod, you'll be able to set your f/stop to f/18 or even f/22, which will give you crisp clarity throughout the image. If you have a remote shutter release, you'll want to use it to avoid the miniscule shutter shake that occurs when your finger touches the shutter. If you don't have a remote, use the timer function to shoot the shot. The clarity of these methods will give you the sharpness that most photographers treasure in their images.

Another thing to consider is the inclusion of people in your shot to give the viewer some sense of the scale of the place. I've been at Schwabacher often when there is an artist sketching the scene - and I often ask if they mind if I take their photo while they work with the Tetons in front of them.

Another option is to take a bride with you to enhance the scene.

If you don't have a willing helper to assist you, then you might want to consider setting up your tripod behind you and taking a self-portrait of yourself sitting on the banks of the river and gazing up at those magnificent Tetons in the distance.

Many landscape photographers will disagree with the placement of a person in a scene, but others will tell you that without scale, it is very hard for a person viewing the photo to gain an understanding of just how massive the mountains are in the Tetons as they jut up from the valley floor.

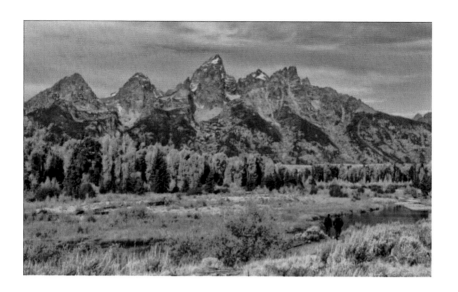

The shot above was taken from the parking lot and you can see the dirt path that the two photographers are standing upon as they take in the magnificent scene before them. I'd urge you to not spend all of your time with a lens in front of your face, but to stop for a few minutes and breathe in the crisp air and let your eyes feast on nature's wonder.

Once you've worked this scene from parking lot to the bank of the river, then you'll want to head north along the dirt path. Many photographers stop at the lot and don't realize that an even more pristine location is just a ten minutes walk up a fairly level path to the beaver ponds.

Okay, so you may be saying at this point that you've got a tight schedule and you want to hit one of the dozen other sites that beckon you. You're not sure you want to invest another 45 minutes at this site as the light begins to climb in the sky. Don't be tempted to leave. Walk the pathway and you'll never regret it.

The path leads you to a stream that has branched off the main river and has been dammed up by beavers. Unfortunately, you'll see that there has been some infestation alongside the west side of the stream that

has killed off a lot of the trees. But there will be a couple of spots as you venture north that will give you a chance to capture a different view of the Teton range with trees reflected in the still water alongside the path.

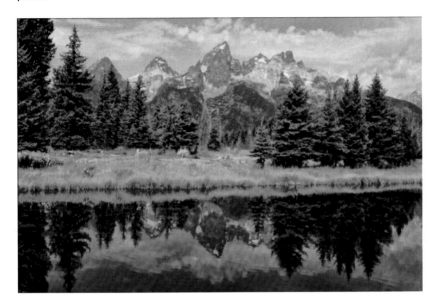

Once again you'll want to experiment with your shooting height as you traverse the pathway. The shot above was taken from a knee high height, which allowed me to get both the tree tops and their reflections in the water. Clouds are a bonus, but you'll find that they can be both a gift and a hindrance as they are capable of obscuring the peaks as the day progresses. The same can be said of residual smoke from area forest fires - which has a tendency to hang at the base of the mountain range until winds blow through the area.

But that's the luck of the draw, and something you can't control during your visit. What you can control is your ability to make the best of the situation in front of you.

As you move on down the path, you'll find the stream widening as the beaver ponds appear. If you're alone as you walk down the path, move

gently and you may be fortunate to see wildlife at the water's edge. But most of the time you'll be there alongside others especially on the weekends during the summer and fall months when Schwabacher sees its largest crowds.

Your ultimate destination is easy to find - the park service has erected a log bench at the conclusion of the dirt path that points west. Sit down before you set up your tripod and take in one of the most magical nature scenes in North America. What you are looking at subject of countless cover photos since the turn of last century.

What makes this scene so special is the trees that frame the Teton range and the fact that you can get such a perfect mirror reflection in the still waters of the beaver pond. There are often ducks on the pond that will swim in your scene, but be aware that their ripples may break up the reflection. You will also want to move alongside the eastern bank of the pond - there are trees on your left that you can get under if you crouch low enough and that perspective will create a completely different shot for you.

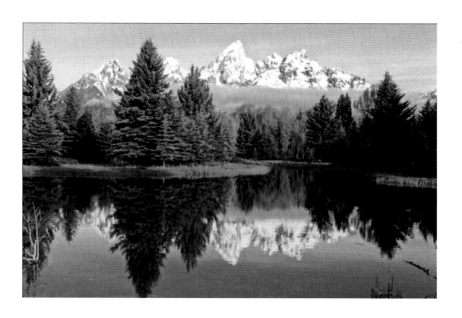

Because of the number of things in front of you and the changing nature of the sky and the light, I'd urge you to bracket a series of shots as you photograph this scene. If you haven't bracketed, it means simply taking a shot that the camera tells you is exposed correctly and then taking another that is under exposed and another over exposed. I normally do this via the aperture setting that most cameras possess. And I normally use a tripod and start out with an aperture setting of f/8 or f/10 and then experiment with settings all the way up to f/22 - all at different exposures after getting the standard exposure that the camera and lens have calculated. When you get home and start processing your shots, you'll often find that a shot other than the correct exposure may actually be a better image.

Once you've gotten your fill of this great location, you could move northward along a much smaller trail that runs alongside the water. However, just north of the bench, the view from the east side becomes one of trees alone as you lose the view of the Teton mountain range. If you're looking for something different, you can experiment with shots in this vicinity.

But if you're pressed for time - and wanting to save the good light for best use - return to your car in the parking lot and drive back on the dirt road headed south for a quarter mile or so until you see a second parking lot on your right (west) side. This is the third photo spot that I referenced at the start of this chapter. Park here and take a moment to check out this alternative scene in front of you. This is known as lower Schwabacher, which is counterintuitive since it is at a level higher than the parking lot at the landing.

Although you're not as likely to spend a ton of time here, there are some great spots alongside the meandering Snake River below that will give you a view of water and the Tetons as the river bends west towards the mountain range. You can shoot the scene from the parking area, but the better shots are taken when you walk down to the side of the river bank and follow it west.

Chapter Three - Hedrick Pond Overlook and the Triangle X Ranch

Our journey continues north as we head up Highway 89 towards a spot that is a photographer's nirvana, but one that doesn't show up on any maps of the area. The Hedrick Pond overlook. This is one of those places that took on a special meaning for me personally because I had only seen one photo from this location during repeated visits to all the photo galleries in downtown Jackson. But what a photo it was - a view from a high point that overlooks the valley and gives one a panoramic view for miles with a beautiful pond as a focal point in the center of the valley.

First things first, however. To get to this hidden overlook will require a drive on a deeply rutted road that is not conducive to a normal rental car. If you have a vehicle that has high clearance - like a large SUV or a jeep, then you're in good shape and you can literally drive to the point where you setup your tripod. Otherwise, you'll need to hike in when the road gets too difficult for a regular car to handle. I made that mistake the first time I visited this spot and now I always get a rental vehicle with high clearance.

Although this particular photo location could also be a sunrise spot, since you'll be facing west towards the Tetons when you shoot, I would recommend it for mid-morning. Two reasons - safety and the ability to have enough light on all of the panorama in front of you. Because of the narrow, rutted road I would not recommend trying to find your way in near darkness. And although a sunrise shot would show good light on the mountains, part of the valley below you would still be in the shadows. So, if you can get there around 9:30 a.m. or 10:00 a.m., I think you'll get a marvelous shot.

If you're headed north from Schwabacher Landing or up Highway 89 from downtown Jackson, you'll simply want to drive until you come to the Teton Point turnout on the left hand side of the road. That will tell

you that you're getting close. Although it also has a beautiful view of the Snake River and part of the valley, I'd recommended you continue northward and watch for a gravel and dirt road on your right that is just before the well known Snake River Overlook. This gravel and dirt road leads to the Lost Creek Ranch and you may see a sign to that effect - although your best bet is to look ahead and see the Snake River Overlook on your left in about a quarter of a mile. You'll know you've found the right road.

Head east on this road and you'll travel approximately a mile and then on your left you'll see a much less traveled dirt road that splits off the main dirt road. You'll want to turn here and head north. And if you're in a rental that won't get you too far, then you can park on the plateau to your left almost immediately and still get a very nice view of the Tetons with a multitude of trees in the foreground. This is also a great place to stop if you're traveling during the fall season when the trees are turning colorful in front of the Tetons.

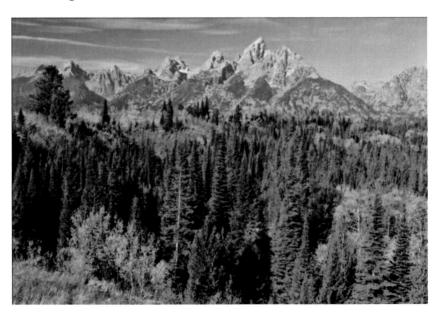

As you can see, the view is pretty darn special here and if you're inclined, you can work this scene for a good half hour as you check out the various angles available looking west and northwest.

But I would recommend stopping only briefly and then continuing your drive east along the ridge. As you drive, you may want to stop at a point a half mile or so from your last stop and shoot the scene to your rear that shows the dirt road atop the ridge and the Tetons in the distance.

Drive slowly and watch for another deeply rutted road that will veer left (west) in approximately 1.1 miles. You should turn here and *slowly* follow this road north and then west as it leads you to an area that has picnic benches and has a flat spot you can park and also turn around.

You've made it and as soon as you get out you'll see that it was worth the considerable effort. You're standing at a spot that probably less than 1 in 10,000 visitors to Grand Teton National Park ever visit, and you've got a wide ranging view of the Tetons and the area that is called Jackson Hole. In fact, I would be surprised if the first mountain men didn't stand right here and marvel at the sight that lay before them.

As an interesting aside, the pond below you - Hedrick Pond - was the site of a movie called Spencer's Mountain back in the last century. It is a credit to the film crew that they returned the pond to its pristine state when they finished the film.

When you take out your tripod, consider using a wide angle lens to capture the scene - and even then I would suggest taking a series of shots from left to right that you can later stitch into a panorama. And surprisingly, I have gotten decent cell phone coverage standing on this ridge in the past, so you may be able to take a shot or two with your cell phone camera and send it out to your friends and family to create "instant" envy.

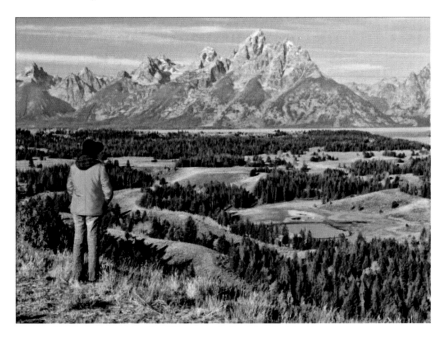

Remember to work the scene from left to right and you'll have to make some decisions about whether to include the tree that stands at the edge of the ridge as a framing device in your composition. Also, if you're able to climb down a bit, you'll find that the angles below the ridge offer some different viewpoints than can be had while standing on top.

I might also suggest you add a person in one or more of your shots, or include yourself in the scene by using the self timer on your camera. As I have mentioned before, the inclusion of a person allows that great thing known as scale - or perspective - to enter into the image. And don't hesitate to take a shot of a person's back as they gaze upon the valley. Future viewers will imagine themselves as that person standing on the ridge.

In terms of camera settings, it is always good to use the standard landscape aperture settings that range from f/16 to f/22 if you are shooting with a tripod and you've got good light. Experiment a bit and even try a radical different aperture setting of f/2.8 or f/4.0 if you're shooting a portrait on the ridge You'll have good focus on the person's face or body and then the limited depth of field behind them will blur the scene as the distance spreads out behind them.

After you've shot to your heart's content and you begin to take your gear back to your vehicle, I hope you'll stop and enjoy this world class view one more time without a lens in front of your face. If you are a lover of nature and landscapes, it is not going to get much better than this in North America.

Once you are back in the driver's seat, retrace the dirt road headed east until you come to the main dirt road and then turn back right which will have you headed south along the ridge for a mile or so. You will then run into the gravel road that first led you to the ridge and you'll want to turn right heading west and drive back down to Highway 89.

My next recommended stop is the wooden rail fence that sits directly across from the road that leads to the Triangle X Ranch - a distance of approximately four miles headed north on Highway 89. You'll probably be tempted to turn out for the Snake River Overlook that is just on your left as you rejoin the main highway, but I'd suggest you bypass this spot today and leave it for a morning dawn shot later during your visit.

As you drive north, you'll notice that you are making a fairly sharp directional turn to the east and then returning in a northward direction. If you look up the hill to your right as the S curve straightens out, you'll see the ridge you were standing on that overlooks Hedrick Pond. Hedrick Pond is not visible from Highway 89 and thus is missed as a photo opportunity by so many photographers as they search out photo spots along the highway.

On your left the valley floor will begin to spread out before you and you'll see lots of brush and the beginnings of a wooden rail fence. Often there will be bison grazing near this spot - and if they are, you'll want to stop and take a few shots. With the right light and correct angle, you may even be able to get them standing in front of the Teton range. But if they aren't present, I'd suggest you continue to drive until you see a large wooden gate on your left and a road to Triangle X on your right. You can pull off on the east side of the road as there is a parking area there that is open to the public.

Full disclosure - like so many locales in this book, this site is also another great sunrise location. However, I'm going on the assumption that you only have a few sunrises in your trip and this wouldn't be my first choice.

That said, there is one circumstance that would make it my first choice - and that's when the wranglers at the Triangle X Ranch move their horse herd from the pasture on the west to the corrals on the east side of Highway 89 at first light. Unfortunately, they don't do this every day or even every week - it all depends on many factors - including weather and Park Service permission. In my ten years of visiting the area frequently, I've only had three separate times when it all came together.

But, when it does, you can get an iconic shot of a herd of horses in front of the Tetons as the first light illuminates the mountain range.

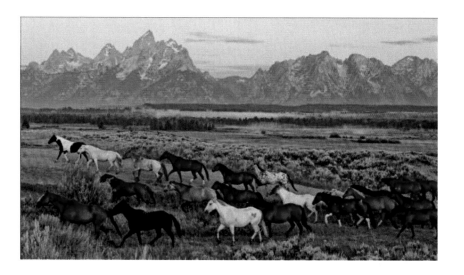

The best way to ascertain if there is an opportunity for this shot is to call the ranch directly at 307.733.2183 a day before and ask them if they will be moving the horses from the western pasture to the corrals in the morning. If you're lucky, they will be and you can join the handful of other photographers who know about this great photo opportunity at first light the next day.

But let's assume that your luck wasn't perfect this time around. You haven't missed out completely because there are rolling hills covered with an old time wooden fence just across the road and they are beckoning you and your camera and tripod.

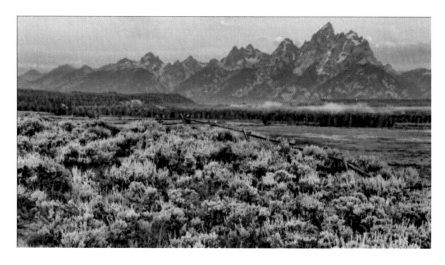

Depending on the time of the year of your visit, you may encounter the various shades of green and brown that dot the landscape via the sagebrush that grows wild in the area. I'd suggest you take some panoramic views and then walk up and down the fence rail as you line up your shots. I've also found that getting very low to the ground and shooting up towards the fence and the mountain range can produce good results.

This is also a good spot to practice the use of bracketing as the many colors of the landscape are so hard to capture with just one frame. Taking several frames that are under and over exposed along with the correct exposure will allow you to blend these when you return home. Of course, many of you know that there are software programs that will do this type of high dynamic range (HDR) blending for you and will help you capture the nuances of color and light that were present when you took your shots.

As you wrap up your shooting at this location, be sure and shoot east as well. It won't be as magnificent as the Teton range, but there are some good shots looking northeast across the road.

We'll continue our photo journey together in the next chapter as we head back south and then east for two places that the afternoon sun will help instead of hindering our photo work.

Chapter Four - Afternoon trek to the Red Rocks and Teton National Forest

If you've followed my recommendations so far, then you've used up most - if not all - of your morning light on some really good locations. Good for you. If you're like so many others before you, you've probably been marveling at all the beauty around you and the magical scenes in front of your camera. And if it is your first visit to Jackson Hole, then I would guess you've already filled up a couple of memory cards with hundreds of images.

Realistically, you may not be following the road - and the text - from chapter to chapter. You may have spent more time at one of the previous locations, or run into wildlife along the way. You may have turned off at one of the many photo ops that you passed on the way to the locations we've covered so far.

No problem. This guide is supposed to help you with your journey and it is written with a couple of things in mind. Some people want to know about a route that will maximize their limited time in Grand Teton National Park. And some people want to know about the hidden and not so hidden places but want to travel at their own pace and make their own route as they go.

Whether you fall in one of those camps or some variation of the two, this chapter is designed to take you to some photo spots that benefit from mid-day and afternoon light. So if you're carrying this text along with you as your travel through the park, you'll want to wait till afternoon to visit the locations in this chapter.

Assuming you're on Highway 89 at the Triangle X at this point, I'd suggest you turn back south and head back past the Snake River Overlook and down to the Moose Junction. You can then turn right (west) and grab a bite to eat at Dornan's - which is just on your right down a short road after you turn off Highway 89. During the summer

they have an outdoor grill that makes a mean buffalo burger and they also have a deli that serves sandwiches, and also a pizza restaurant that has a second floor dining area that gives you a stellar view of the Tetons as you eat your lunch.

There are also restrooms near the big teepee that you'll see on the western side of the parking lot.

Once you've refueled your body - and your vehicle at the gas pumps if necessary - it's time to head back to Highway 89 and continue south past the Airport and watch for the Gros Ventre Road intersection that runs east and west. You'll want to head east towards the town of Kelly when you get to this major artery that will take you out of Grand Teton National Park and in to the Teton National Forest.

As you drive east, you'll see the Gros Ventre River running parallel to the road. There are a couple of pullouts on your right and it is worth stopping briefly to see if there are any moose feeding on the willow trees that line the river. And of course if you see a lot of cars pulled over, then that will be a strong indicator that wildlife are present.

Continuing east you'll drive through the small town of Kelly, Wyoming and then the road will turn left (north) and you'll see pasture land on both sides of the road. Often there are bison grazing here and so you may want to stop if the herd is in this vicinity and get some shots.

Of course you'll want to use a long zoom (300mm) or prime lens (400mm) if you have one to get a good close-up of a bison. Bison are docile most of the time if you keep your distance, but if they sense you are too close, they'll definitely charge. So stay safe and stay a good distance away from them. In fact, a Park Ranger told me that there have been more deaths in National Parks from bison attacks than from bear attacks and whenever I find myself moving toward the bison to get a better shot, I recall his story and it reminds me to keep lots of space between me and the 1400 lb animal I'm photographing.

If you don't run in to bison here, don't worry - there is a large herd that stays within the confines of the park and you'll be bound to run into them at some point as they graze in the open fields that traverse the Jackson Hole Valley.

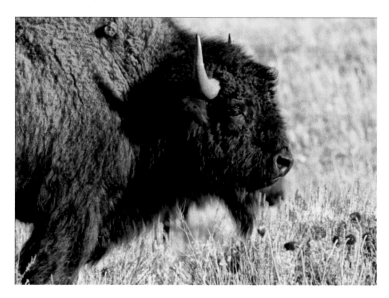

As you head north out of Kelly, watch for a road on your right and turn east when you come to it - it is called Gros Ventre Road not surprisingly. Immediately after you make your turn, you'll notice a parking area and that's there because there is a prairie dog village on the south side of the road. Although prairie dogs (or ground squirrels) don't have the allure of a bison, if you're traveling with kids then it would make sense to stop for a few minutes and stay quiet and you'll see the little fellows emerge from their holes.

Continuing east on Gros Ventre Road you'll soon encounter a couple of broken down wooden cabins on the left (north) side of the road. Although they are in poor shape, they do have some interesting background and they might be worth a stop if you're so inclined. This is the old set where they shot all of the ranch scenes for the famous western movie called Shane. And yes, it's okay to explore the cabins, as this is still public land. If you do decide to get out and look around a bit, you'll find that you can get inside the remains of the cabins and shoot

through the open windows looking west. There you'll just be able to make out the peaks of the Teton mountain range. If you climb the ridge to the north of the cabins, you'll have a better shot of the mountains.

When you commence your drive east you'll notice that you'll be leaving Grand Teton National Park and entering the Bridger-Teton National Forest. There is a parking lot near the sign that announces your arrival to this new area and if you stop, you can get a couple of good shots of the rolling hills to your north that are different than the landscape you've encountered so far.

I am personally always fascinated by a lone tree on a ridge. and I think it makes for a good landscape photo opportunity. And since you are shooting northward the bright sun above is actually much more helpful than you were trying to shoot west.

As you continue your drive east you will notice that the road goes from being paved to being simple gravel. If you are in a rental car, don't worry because the road is well maintained and you're not going to run in to any major ruts as you drive. But you'll want to adjust your speed,

especially when there are cars coming towards you from the east that will kick up lots of dust that will obscure your view for a few seconds.

About five miles in and halfway to your ultimate destination, you'll see a large lake looming on your right (south) side - this is Lower Slide Lake. The road you are on will take you high above this lake and there are some stunning views if you'd like to stop and grab a few shots.

The lake is also home to many different types of birds - including eagles - that can often be seen perched on the dead trees in the center of the lake as they hunt for a meal. Unless you have a long lens (400mm or longer), you'll not be able to get a decent shot of them, unfortunately.

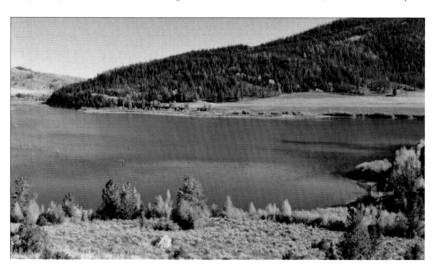

There is a campground called Atherton Creek on your left as the road descends and it's tempting to turn down the road there and take some shots of the lake looking westward. I'd recommend that you don't stop, however, as you'll be frustrated by the light since you've most likely driven this way in the afternoon.

Your best opportunity to get some great shots is just beyond the lake and you're now about a fifteen or twenty minute drive from the less than well known Red Hills.

The road narrows again and you'll see on your left (north) as you head east that the hills are beginning to take on a red hue that is different from anything you've seen so far. The mineral composition in the soil here turns the hills into varying shades of red and you'll be tempted to stop as soon as they begin to appear, but I'd urge you to continue forward and the road will rise in front of you. At the top of the rise you'll see a parking area on your right that you can park in and take in the full magnificence of the Red Hills spread out in front of you. Here you'll see a magical panorama with a valley full of horse farms and those amazing Red Hills jutting from the valley and begging you to set up your tripod.

For this scene, you'll want to use a wide angle lens if you have one and you may also want to take several shots in succession from left to right so you can stitch them together when you return home.

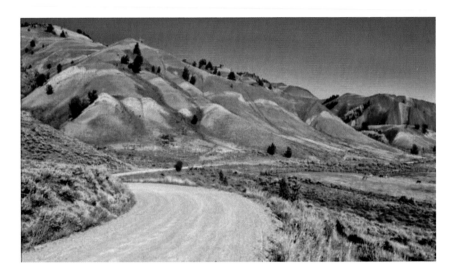

Although not necessary, this spot is a good place to use a neutral density filter or a circular polarizer on your lens to cut down on the bright light above the hills. I normally use a warming circular polarizer that does double duty and is an effective tool for a landscape photographer. They come in almost all lens sizes and there are many different brands and prices for all budgets.

You'll probably want to take a lot of different angles from your high vantage point and I would once again urge you to include the road in some of your shots. The horses on the right will definitely give the scene the scale you are wanting, but I find that the vanishing point effect that is created by the road running seemingly into the hills is an effective visual bonus for the viewer.

After you've taken plenty of shots up high, I'd suggest you continue your drive east and you'll come to a dirt road on your left that drops down rapidly headed south. I usually will pull my vehicle over here and take my gear and hike down a few hundred feet to the southeast to get a shot of the Red Hills looming over me as I shoot from the valley with the horse farm and fences in front of the lens. If you're lucky you're apt to have a few horses come over to the fence and investigate if you have any treats for them and you can snap off a shot or two with them in front of the Red Hills.

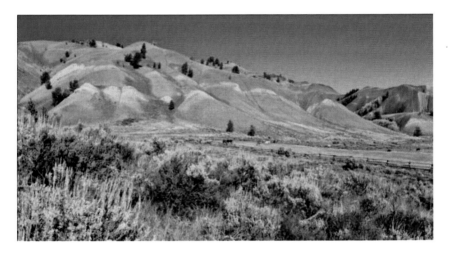

If you haven't already done so, look over your shoulder behind you as you return to the car and the road above and you'll see some beautiful photo opportunities. Spread out in front of you will be the Gros Ventre River and the heavily forested hills.

Once you're back in the car, head down to the eastern edge of the Red Hills and shoot some photos northward that will give you a completely different perspective of this amazing geological formation.

If you started out for this spot at noon, you're probably pushing the 3:00 p.m. hour by now and I'd suggest you retrace your route headed west this time until you rejoin Highway 89 at the Gros Ventre Junction in Grand Teton National Park. It will probably take you the better part of an hour to get back to the main highway.

Once you get to Highway 89, head to town or the place you're staying while in the area and rest a bit or review your shots from today. Then grab an early dinner so you can head back to Moose-Wilson Road for some wildlife viewing as the light begins to fade during the early evening hours. Wildlife tends to come out to feed during the early light and twilight hours and you'll never know what you might find.

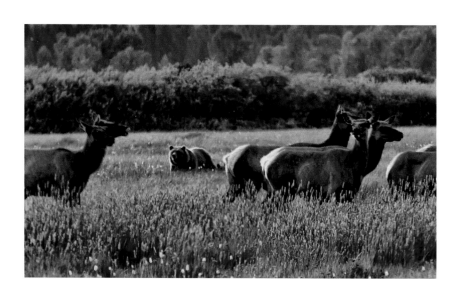

Chapter Five - The Barns and Mormon Row

We'll be covering one of the most famous photo locations in the world in this chapter, but one that won't show up on your official National Park Service map of Grand Teton National Park. And that's one of the reasons that this book exists, because of the simple fact that the iconic Moulton Barn in front of the Tetons literally isn't on the map that everyone gets when they visit inside the park on their first visit.

I can't tell you how many emails I get on a regular basis from fans of the Tetons telling me that they visited the park and never saw the barns. It has probably been mentioned to me a thousand times or more. And the sad thing is that they were so close when they traveled through the main arteries of the park.

I'm assuming that you're headed out at least an hour before first light from your hotel in downtown Jackson. You'll be driving north on Highway 89 and the trip is approximately 27 miles from downtown to the two barns. But you'll need to allow yourself more than 30 minutes because the speed limit is only 45 or 50 miles per hour throughout the park. And as you head north you might easily encounter elk or moose or bison feeding near the road in the moments before dawn - so watch carefully as you make your trek.

You'll be driving past the airport junction and Moose junction and you'll be looking for a sign that says "Antelope Flats Road" on your right about a mile north of the Moose Junction turnoff. Here's a hint - almost directly opposite of this road on the west side of Highway 89 is the Blacktail Ponds Overlook - and I'd suggest you make a quick detour to see if there are any moose grazing in the meadow just below the parking lot. I have found that the abundance of willow trees in this area makes this a magnet for moose during the early morning hours.

If you see a moose, great - set up you tripod and begin shooting from the relative safety of the ridge. But if no moose are present, I'd urge you to jump back in your vehicle and head east on Antelope Flats Road right away as you will want to be all set up as the first light hits the southern Moulton Barn.

To access the barn, you'll want to turn right when you encounter the dirt road that heads south about two miles east from the intersection of Highway 89 and Antelope Flats Road. This road is known as Mormon Row because it was where the first Mormon settlers set up their homes and ranches in the early 1900's. And to say they knew a little about the old real estate adage of "location, location, location" would be an understatement.

As you head east approximately a quarter of a mile you'll see the outline of Thomas Moulton's barn on your right. If you are visiting during a holiday weekend or during the fall season, you will also probably see a half dozen cars parked ahead and at least that many photographers set up alongside the fence in front of the barn.

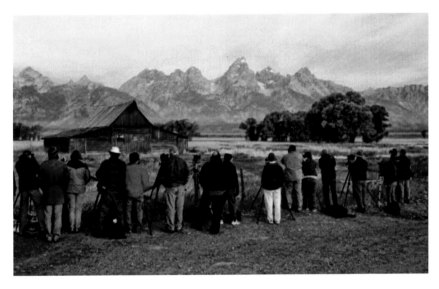

Don't worry, it's not always like the scene you see above and I've been there many a morning when there were only a couple of other photographers present. And the key thing is that you are now personally standing in front of what a couple of magazines have called "the most photographed barn in the world".

That said, I'm going to tell you my own personal bias. I've been to Grand Teton National Park many, many times and I would never miss the opportunity to shoot at least one morning at the barn. The light is always different, the clouds and weather are always different and the crowd is always different. There is an electricity in the air as the first light begins to illuminate the peaks in front of you and then more great vibe when the weathered old barn starts to light up at sunrise.

One of the questions first timers ask often is if the barn is on private property. And the answer is no, it is on land that is part of Grand Teton National Park and thus you are free to roam around and cross over to get a different perspective than the one you get from shooting behind the fence. What I find truly amazing is that in the early 1970's the Park Service was considering an option to tear down the barn as an "eyesore" in the park. Luckily, a handful of local photographers got together and worked to preserve the barn and today it is truly the most iconic symbol of the area - and the old west - in the western United States.

I personally have three separate shots that I take when I visit and all offer the photographer a chance to get something other than the traditional head on shot with the barn's peak mirroring the peak of Grand Teton behind it. I'd recommend you once again use a tripod and a remote shutter to reduce camera shake - which is especially important in the early morning when you will be shooting with little light present. And if you don't have a tripod, you can set your camera on one of the wooden fence posts to stabilize it.

My first shooting setup is to go over to the trees on the left hand side of the barn and position myself and the tripod low to the ground. If there

has been rain in the area recently, there will usually be a bit of water present that you can use to lead the viewer's eyes back to the barn and the mountains.

Most people tend to try to shoot through the trees and their composition does not include the trees, but I'm a contrarian and think that the trees add some balance to the barn and the mountain range. This is especially true if there aren't a lot of clouds present when you are shooting. I would recommend you try several different zoom lengths from panoramic to focusing solely on the barn and the mountain peaks behind it.

And remember to stay low. It seems like most photographers like to shoot at comfortable levels like at their chest or in front of their face while they are standing. That makes sense from a comfort viewpoint, but it definitely hampers your creative ability. If you get down low, you'll probably have a creak or two in your joints, but my guess is that you will be quite happy with the results when you view them later.

After working this scene, I would move back to your right (north) and set up a shot that has the second stream or gully in the foreground. This one is on the right side of the barn and is another item that is often overlooked by the first time visitor who is content to stand behind the fence and shoot away.

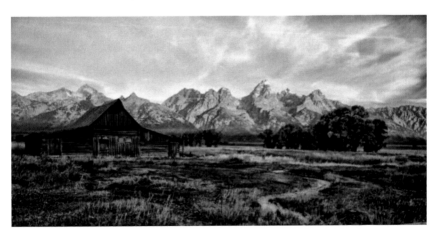

This is another place where I would once again urge you to get low and stay low as you line up your shot. If you are present at the end of the summer or in the early fall, you will have the opportunity to use the brown and tan sagebrush in front of you to create some depth in your image. This will lead to the magic layering effect of foreground, mid ground and background that landscape photographers strive for in their compositions.

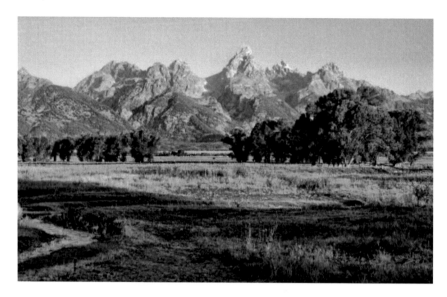

And here's a radical thought - what about leaving the barn completely out of the scene and just use the trees across the meadow from you to frame the Teton range? That's actually my third favorite spot when I visit the southern barn and try to shoot something different that takes advantage of the truly stellar landscape that is spread out in front of you.

In terms of aperture settings, I would suggest f/16 if the light is good at this spot and assuming that sunrise is behind you. You'll have to adjust depending on your light and weather conditions, but you'll want to try to get sharp detail from the front to the back of your shot.

Next, I'd urge you to jump in your car and drive north about a quarter of a mile to the second Moulton Barn on Mormon Row. Yes, there are

actually two barns built by two brothers that dot the landscape here and the second one has some real character all of its own.

This barn was built by homesteader John Moulton around 1911 or 1912 and is often referred to by photographers as the northern barn. What makes this barn different than the barn you've just left is that this barn has a corral and a different backdrop from its more famous sibling to the south.

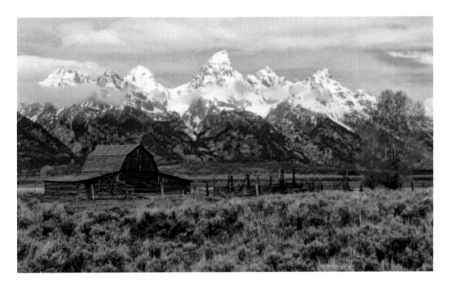

And like so many things in the photography world, the amount of clouds and light you have will make a huge difference in how you want to set up your composition at this barn. Many photographers head up close, but I prefer to walk out in the field covered with sagebrush and use that brush for foreground interest in my shots.

You'll probably want to experiment with different compositions - with and without the tree on the right is always a big question. I personally like it as a framing device for the mountains, but you might find that a zoom in shot with the barn and the corral sans tree is more your cup of tea. But either way - stay low. I know I sound like a broken record on this subject, but I can assure you that it is one of the things you should

consider on every landscape shot you take during your visit to Jackson Hole.

Another thing to consider is whether you want to include any of the out buildings that are just to the left of the barn behind a row of trees. I have seen some panoramas done that included these and that's a matter of taste as well. I prefer the barn alone because it really gives an old time western feel to the landscape. And to think that at one time that was a new barn just completed by the Moulton brothers and there wasn't a photographer anywhere to be seen.

If you do decide to move in closer to the barn, be considerate of the fact that there will likely be several other photographers shooting at the same time you are setting up you shot. When I'm there, I always announce to anyone within earshot that I'm going in for a couple of shots but I'll be back out within a few minutes so as not to spoil their shots.

But don't be surprised if others aren't quite as neighborly. I've had many a good shot spoiled by another photographer walking blissfully unaware right in to my shot as he or she pondered their own shot. It's a fact of life at the barns and don't let it get you down. It is still early in the morning and you've got lots of good light left.

Once you have filled up one of your digital film cards - and you probably will - then I'd suggest you return to your vehicle and head back to Highway 89 by driving west a couple of miles. While there are photo opportunities all around you, I'd suggest we turn left at the highway and head south to the Moose Junction and then turn right as we head for the interior artery within the park - Teton Park Road.

We'll cover Teton Park Road in detail in the next chapter.

Chapter Six - Teton Park Road

Teton Park Road is the second most traveled road within Grand Teton National Park after Highway 89. It runs near the base of the Teton mountain range for almost 20 miles. It begins its journey at the Moose Junction, heads north/northwest and it ends at the Jackson Lake Junction on the eastern shoreline of Jackson Lake. During those miles, you'll experience a whole different perspective because of your proximity to the mountains and there are almost a dozen pullouts that are worth exploring.

However, we're going to concentrate on the handful that you can shoot in a three hour period before the noon sun gets a bit too harsh for good landscape photo work. We'll assume that you spent your sunrise hour at the barns on Mormon Row and you are ready for some different views in front of your lens.

As you turn west on Teton Road from the Moose Junction off Highway 89, you'll cross the Snake River within the first half mile. Once again, you'll want to drive slowly and watch both sides of the road for a moose spotting. Because of the abundance of willow trees, this is a location that has more than its fair share of moose and they can often be seen alongside the river. Of course, you probably won't have to look and listen too carefully, because if there are moose present there will be a moose jam with cars lining the road.

As you cross the river, you'll continue west past the visitors center which is a great place to visit when the afternoon light makes photography less than stellar. You will then come to the ranger entrance where you'll have to pay your fee to enter this part of the park. The fee covers you and your vehicle so if you have more than one person in your party, you'll pay one set price.

Immediately after the entrance, you'll want to take an immediate right turn on the paved road that leads to the Chapel of the Transfiguration. You may want to get a shot of the chapel with the Tetons in the background, but I prefer the scene on the western side of the chapel. So, when you see the chapel on your left side as you head east, I'd suggest you pull over and take your tripod to the field just behind the chapel.

There you will see a grove of aspen trees that are on a slight ridge in front of the mountains and this makes a very compelling image - especially during the autumn season when the aspens will turn various shades of color.

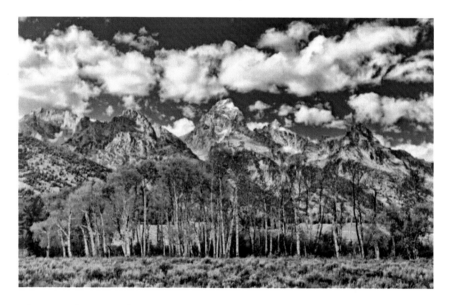

After you have worked this scene from the meadow, I'd suggest going beyond the aspens to the west where the view without the trees is also a good one of the Teton range.

Then you can either walk or jump back in your car and head east to the parking lot that sits on the north side of the entrance to the chapel. If you drive, park there and get out and walk on the path headed east to the ferry landing. The big opportunity here is the two stores that sit on the path. On the backside of these stores are windows that will reflect

the Tetons perfectly if you can get the right light and angle to set up your shot. This is a shot that will separate your images from those of others because it is virtually unknown. I stumbled across the idea when talking to an old timer at the pond on Moose-Wilson road during one of my visits, and he said that he thought it was one of the unique shots in the park. I agree.

You'll want to experiment with your lens and tripod because it is a tricky shot. If you get too far in front of the window, you'll be in the shot and if you get too far to the left or the right, you will lose the reflection. You will also want to take some different aperture and focus point shots - some with the window frame in clear focus and some with the mountains in focus and the window frame out of focus.

If you then walk about one hundred feet west from this location to the service road that runs north, you can follow it for a short distance and you'll have another nice view of the Tetons that you can shoot with the trees framing the shot in the foreground.

Then it is time to get back in your vehicle and drive west until you run back into Teton Park Road where you'll turn right and head north. At the Windy Point turnout, I'd suggest you make a quick stop by parking on the lot on your right and taking your camera and lens to the west side of Teton Park Road. Be careful about the traffic, but if you can pull it off I'd suggest you get a shot of the road as it heads north headed directly in to the base of the Tetons.

Many, if not most, photographers want to get a shot without the road but I'd once again suggest that you need some scale to let the ultimate viewer see just how massive the mountain range is versus the road below it. For those new to photography, this type of shot is called a vanishing point image as the road appears to vanish as it heads into the distant mountains and landscape. There are several spots in the park that you can pull off this type of shot safely, and in the mid morning light you can usually get a fine shot at this particular turnout.

The next major stop is a breathtakingly beautiful scene where you will have an opportunity to catch one or more horses feeding in a meadow in front of the Tetons. There is a parking lot on the east side of the road and you can park there and head across the street to set up your shot.

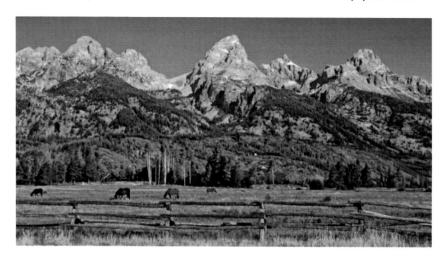

One of the major decisions you'll have to make at this location is whether you want to include the fence or not in your landscape photo.

I would recommend you take some shots right at the fence line and some farther back to include the old wooden rail fence. I personally think the fence adds to the old west feel that the scene portrays. And you'll want to use your tripod, a relatively wide angle lens such as a 18 to 24mm and an aperture setting of f/16 if it's a sunny day. And of course if you're relatively new to photography, you can get a pretty darn good shot by using the auto setting on your camera.

The horses are park service animals and they are normally present in the meadow during the morning hours. However, you may drive by when they are absent and then I'd suggest you return to this locale when you seem them in the field on one of your many excursions up and down Teton Park Road. It is a pretty scene without the horses, but the horses are the proverbial cherry on top of the sundae that you want to include if at all possible.

One other hint that most photographers don't know about is that if you walk to the north, the fence begins to turn westward and you can get a nice shot of the fence and the trees with the mountain range.

Once you hop back in your vehicle, we'll continue north/northwest for a few miles and you'll see a concrete bike path that has been built on the west side that parallels the road. If you are so inclined, pull off when you see a rider or group of riders and get a shot or two from the east side of the road with the bikes at the base of the Tetons. Once again you'll get that scale that we are always wanting to include in a scene.

As you drive north you'll see Jenny Lake and the visitor center on your left and I'd suggest you pass it by this morning and continue north. We'll cover Jenny Lake and Leigh Lake in another chapter, but to maximize your photo productivity this morning, your best bet is to keep moving north. There are several turnouts that exist on both sides of the road and I know it will be hard to keep on driving. But I think you can get your most impressive shots past the North Jenny Lake Junction which will be about four miles north of the first Jenny Lake turnout.

The reason I suggest the effort to head north is that you get some of the best perspectives in the area between the Mount Moran Turnout and the Potholes Turnout. Stopping at these points or pulling off the road anywhere between them will give you a terrific view of the Teton mountain range with a vast prairie below it. I think that when most people see this vista for the first time, it takes their breath away and it is a great place for taking wide angle landscape photos.

I personally like shots from the Mount Moran turnout if you walk about 75 feet west/southwest of the parking lot and set up your tripod in the vast field of scrub brush and sage. And remember to take a few shots with the tripod at its lowest setting so you can get the foreground interest of the brush inside the frame of your shot.

I would then suggest going down the road and pulling off when you have some room and waiting for a clear moment on the road when

there aren't any cars present. You've got another fine opportunity for a vanishing point shot and the landscape makes this area perfect for this type of image.

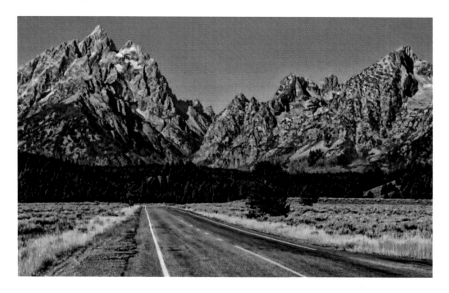

What you are looking at from this location is called the Cathedral Group because the first visitors to the area thought that the mountains and their peaks looked like the vast spires of the old churches found in Europe.

As the morning light winds down, you've got another hour or so and I'd suggest you continue your drive north and head to a location just past the Signal Mountain Lodge where you can pull over and get a superb shot of the mountains reflected in the lake if the winds aren't too strong. The parking is on the west side of the road and the view will be off to the west/southwest. You will want to work this scene from both the road and then hike down to the shoreline of the lake for a different perspective.

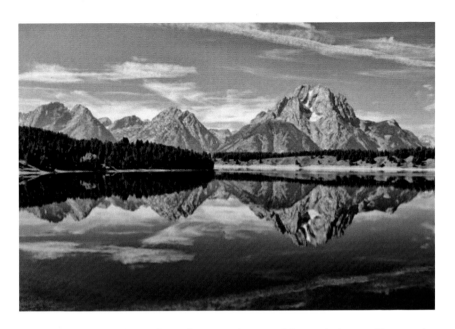

And as you've used so often this morning, a wide angle lens will come in very handy here as well. If you don't have a wide angle, just remember to take a series of shots with the lens you do have while panning from left to right using your tripod. You can then stitch them together later in a post processing step that will give you the magnitude of the scene that appears in front of you.

If the wind has picked up too much to get that mirror reflection that you're looking for in this scene, I'd suggest you make a mental note of this location and plan to return here at another time when you can nail the shot that you want. But if you're pressed for time and you may not pass this way again, then you'll want to get a few shots here because it gives you the best scenic view of Mount Moran from the Teton Park Road. This is the same Mount Moran that will show up again when you visit Oxbow Bend, but this particular view isn't as well known as the iconic view at Oxbow.

And as we close out this chapter, I'd suggest that you take some shots of this scene with the thought of converting them to black and white or infrared using post processing. Because of the elements of this scene, it works pretty darn well and creates a sort of timeless appeal that speaks to many photographers - and fans - of Jackson Hole, Wyoming.

Chapter Seven - Afternoon side trips to Two Ocean Lake and Pacific Creek Road

Well, if you've been following along on a day by day basis, then this chapter will find you on the second afternoon you've been in the park. You've captured some stunning views and you've got lots of great locations left, but the light is overhead now and most shots taken looking west will have that notorious flat light from this point forward. If you're skipping around amongst the various chapters, file this one in your mental bank as an afternoon recommendation for one of your days at Grand Teton National Park.

So, assuming you are just finishing up at the shore of Jackson Lake you've got a couple of options. You can head back to downtown Jackson for some food, fuel and rest or you can head north and east a bit and take in two little locations that are once again off the proverbial beaten path. I shoot as much as I can when I'm in Jackson Hole, so I always carry water and protein bars with me so I can push forward with more photo work. But if you didn't bring any of that with you, you might want to go back to the Signal Mountain Lodge and grab a sandwich before you head out northward.

You'll follow Teton Park Road across the Jackson Lake Dam and you'll come to a junction - you'll want to turn right (east) at this junction and you'll find yourself on Highway 89 and Highway 287 as it passes by Oxbow Bend on your right in less than a mile. Now the temptation will be overwhelming to stop here because you'll be seeing one of the most famous locales in North America on your south side.

And I'd suggest you do so for a few brief minutes. Not necessarily to take any shots just right now because the overhead sunlight will be harsh, but to get a sense of the layout of the shooting location. You'll be headed back here during the pre-dawn hour on your next morning trip from your hotel or campground and in the midday light you can get

a sense of where you will want to setup your tripod. We'll cover Oxbow Bend in an upcoming chapter, but since you are driving past it you'll want to see what is it all about.

And you'll also want to look south over this bend in the Snake River because often you'll see moose in the distance grazing on the shoreline. One of my favorite shots occurred here around noon when I happened to glance over and see a moose feeding quietly in the distant water. No one else seemed to have spotted him, and I didn't have a really long lens with me so I used what I had and got a nice shot of the bull silhouetted within the context of his surroundings.

Once again a combination of luck and knowing where to look paid off and I'd urge you to be constantly aware of the possibility that you may see wildlife at anytime in the park.

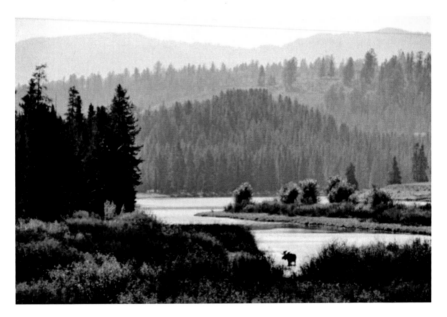

After checking out Oxbow Bend, you'll be heading east again and you'll want to watch for a small sign on your left that will say Pacific Creek Road. This road will lead you north to a split in the road that will allow you to veer left or right. I'd suggest you veer left first and drive the

gravel dirt road north/northwest to its completion where it dead ends at Two Ocean Lake.

You are now on the banks of an unusual lake that drains to both the oceans east and west because it lies directly on the Continental Divide. Although you cannot see the Teton mountains from here, you are in an area that many of the local horseback riding outfitters utilize for trail rides. It is easy to understand why they ride here when you consider the scenic beauty and its remoteness from the crowds that can invade the park in the summer months.

And because there is much less population density in this spot, you'll have a much better chance of spotting wildlife along the road as you travel to the lake, so drive slowly and keep your eyes and ears open.

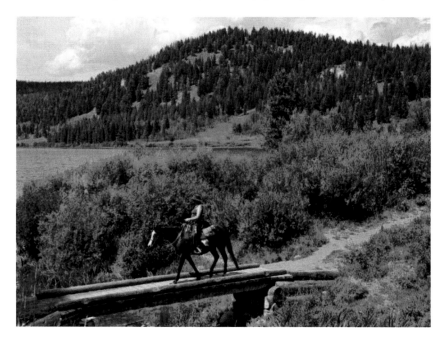

Once you get to the southern shoreline of the lake, you'll see a picnic area with restrooms and a small parking lot on your left. Park here and take your gear and head down to the shoreline and you'll see a trail that meanders around the eastern side of the lake. If your timing is right, you'll see riders on the trail.

One caution - this location has a lot of insects and so you'll need to come equipped with bug spray to keep the flies at bay. You can walk on the trail as it curves northward, but some of the best shots are simply shooting north from the campground and shoreline of the lake when the sun is illuminating the distant tree covered hills. And don't wander too far off the trail because there are a lot of bears that inhabit this area and bear sightings occur here on a regular basis during the summer and fall months.

Hopefully you'll see a bear or a deer or a moose at a far enough distance to get a good shot without your adrenaline pumping too much. And I do hope that when you visit here, you'll put down your camera for awhile and just take in the mountain air and the view around you. You may find yourself catching your breath occasionally since you are near 7000 feet in elevation at this point.

Once you've worked the location, you should hop in your vehicle and retrace your route headed south until you come to the Pacific Creek Road again. This time, turn left and head eastward. The road ultimately dead ends at the far eastern edge of Grand Teton National Park. You'll see a creek on your right as you weave in and out of the woods and you'll have a terrific opportunity to view wildlife since this portion of the park is seldom visited by summer tourists. There are several turnouts that will allow you to park your car and get out and do some exploring - which I would encourage you to do as long as you are aware that wildlife is all around you although you may not be able to see it initially. Walk slowly and listen intently and be sure an look up because since there is water nearby, you may be able to spot osprey or even eagles as they fly overhead in search of their next meal.

Once you get near to the end of the road, you'll want to park and walk through the trees on your right and head east/southeast to the creek's edge. As you look back to the west, you'll see glimpses of the Tetons through the trees.

After exploring this section, you are in good position to get some landscape shots with the river flowing eastward while the sun continues to give you good light in that direction. Although you may want to catch the Tetons to the west, the best shots are actually of the natural landscape, trees and river looking south and east.

After awhile here, you'll want to head back west on Pacific Creek Road and you'll see some great views of the Tetons as you drive along the gravel road. Although the sun won't be in your favor, you will probably want to snap a couple of shots from this perspective as it is another view that very few people see - or photograph - within the park.

This is especially true if you are visiting Jackson Hole in the autumn season when the abundance of aspens alongside the road will allow you to get some seasonal shots. Hopefully, the photos you take will help convey the beauty to others when they see your images taken along Pacific Creek Road.

As you rejoin the main highway, you'll want to turn right on Highway 89 and drive east to the Moran Junction. From there you'll want to turn right and head south on the highway and watch for a dirt road on your left not too far after you cross the Buffalo Fork of the Snake River. It is unmarked, but it is public property still and you want to turn and head east on this road.

As you drive, you'll notice that you'll come up on a clearing that has both fences and some old buildings. You can continue to drive east and don't be surprised if you run into bison alongside the dirt road. This is one of their favorite spots within the park and I've seen bison here many, many times. As long as you're careful, you can get some really close up shots of them by staying in your car and using it as a photo blind. Just roll down your window and put your lens on the windowsill to serve as a temporary tripod and shoot away.

You'll want to try lots of different exposures because the bison are so dark that it is hard to pick up details of their massive bodies.

If there's no bison to shoot, you've still good one good option left before headed back to downtown Jackson.

Just east of the old buildings, you will see a stream and some small ponds that are on both sides of the rutted road. You can drive further east, but unless you have a four wheel drive, it may be tough. However, if the weather and clouds are cooperating when you arrive here, you can get some great reflection shots of the eastern and southern low lying mountains. Just be sure and get down low and experiment with some different angles.

Okay, it's not the Tetons - but if you're looking for a way to use the afternoon light, then this is definitely an option versus shopping at the Square in Jackson.

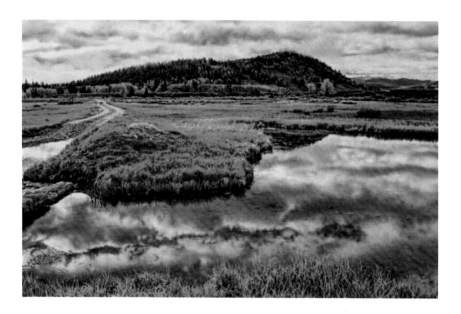

Because the road gets iffy from this point forward, I'd suggest you turn around here and head west back towards the main highway. As you drive in that direction, you'll notice that you've got an unusual viewpoint of the top of Mount Moran with a small ridge and some trees in the foreground. Although you'll be shooting into the sun, if you bracket your exposures (one exposed correctly, one underexposed and one over exposed) while using your tripod, you can get a series of shots that you can blend later into a high dynamic range image that won't be too bad in spite of the less than stellar light conditions present in the afternoon.

Once you rejoin Highway 89, you'll want to turn left and drive south back to Jackson. But you will utilized your afternoon wisely and you'll end up with some photos that most photographers never had the chance to take because they didn't drive off the main highways.

Chapter Eight - Morning at Oxbow Bend

Well, if you've been following these chapters sequentially you've probably already asked yourself a couple of times a very salient question.

"What about Oxbow Bend?" or "Is he ever going to write about Oxbow Bend?"

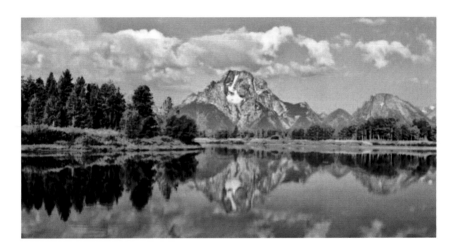

Whether you've been to Grand Teton National Park a dozen times or this is your first, you probably already know that Oxbow Bend is one of the truly great landscape photo locations in North America. It regularly appears on the cover of travel, nature and photography magazines and it is a magnet for even the most casual photographer.

I believe that you can get the best shots of this location by being there early - as in at least a half hour before official sunrise. So, wherever you are staying, plan to head out with sufficient time to get there before first light. If you are staying in downtown Jackson, then allow for approximately 45 minutes driving time when you head north on Highway 89 and then continue west when the highway turns left at the Moran Junction.

If you have any mobility issues, this shouldn't hamper you one bit as you can actually shoot Oxbow Bend from inside a car. There is a parking lot where the majority of shots are taken, but there is a pullout area just west of the parking lot on the south side of the road that would allow you to compose a pretty decent shot without leaving the comfort of your vehicle.

I wouldn't suggest that be your only shot, but it's definitely an option.

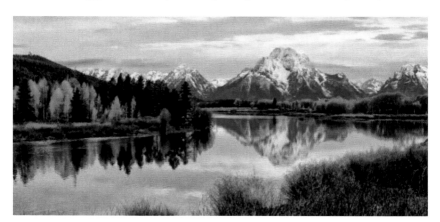

One of the most fascinating aspects of Oxbow Bend is that it contains so many elements that landscape photographers love in a place - a natural beauty coupled with foreground interest, a strong middle point and a magical reflection that captivates a viewer.

If you've not been to Oxbow Bend, some clarification may be in order for you. You are actually looking at a bend in the Snake River that occurred naturally a long time ago and created a body of still water that is perfect for creating a mirror effect. Now that mirror effect is not always present because the winds pick up often in mid-morning, but if you are there early for first light, then your likelihood of getting the reflection is much improved.

You'll want to set up as you have before - with a tripod and a remote release shutter trigger if you have that type of gear. If you don't have the remote, just use your timer to take the shot as opposed to pressing the shutter button with your finger. And you'll want to use an aperture setting of f/8 or better, and thus the need for a tripod in the low light of sunrise becomes really important. Don't be surprised if your camera's internal light meter ends up taking a slow shutter speed shot to compensate for the lack of full light.

I would also recommended that you start at the well worn ridge just west of the parking lot for your first series of shots and that you bracket once again with correct, over and under exposures that will allow you to work with high dynamic range post processing. You'll want to take a minimum of three shots with this method, but using a five photo bracket would also work well here. In fact, I know of several landscape photographers who have taken as many as nine bracketed shots at this spot.

This is one of the places where you can also get a sweeping panoramic shot by using your tripod and shifting the view from left to right. Taking multiple shots with an overlap of about a third of the image between each frame you take will give you a great opportunity to merge them all into one magnificent panorama for your home or office.

And don't hesitate to rotate quite a bit to your left when you set up your panorama as the trees on the southern bank of the Snake River are a good anchor for the image. Too many first timers try to zoom in on the distant Mount Moran and its reflection - which is a fine shot in itself - but they neglect to include a broader sweeping view of the area.

One of the things that you'll always want to remember at a place like this is that you want to capture not only the shot you see in all the postcards of the area, but a shot that you haven't seen anywhere else.

Okay, let's say that you've just pulled into the parking lot and there are heavy clouds present that cause you to sigh a deep sigh of disappointment. I've been there and I've heaved the same sigh a number of times. But I have also learned that weather is constantly changing and the presence of clouds can end up being a beautiful gift for a photographer.

The clouds may not break as the sun rises over the eastern hills, but you won't know until you stay for awhile and see what type of nature luck occurs this particular morning. I was once set up on the ridge with my tripod and I saw dozens of photographers stop, decide it wasn't worth the effort, and drive on.

But a few short minutes later, there was a break in the clouds and a bolt of light shot through that enabled me to take a shot that has appeared in publications all over the world and is a constant best seller. I recall being the only person on the ridge that moment and I was very glad that I had not given in to my thought that maybe I wasn't being very smart standing here when all these other photographers had bailed out.

As we discussed in Chapter One, a great way to improve your photography is to stand in front of better things, and at Oxbow Bend you are standing in front of one of the best scenes you'll ever have in front of your camera. So don't worry so much about the clouds, the weather, or the other photographers. Concentrate on creating an image that reflects the scene right now while you are standing on the

ridge and every time you look at the shot, you'll remember the moment.

The next point you'll want to relocate to would be to follow the well worn trail to the water below the ridge. Be careful, since it's a fairly sharp decline, but it is well worth the effort to get to the shoreline.

When you get to the northern shore of the river, you'll notice that you're not the first one to have ventured down here. It is probably safe to say that you are walking in the footsteps of hundreds of thousands of other photographers who come to Oxbow Bend year after year. That said, there are only two people to consider when lining up your shot. Yourself and what visually appeals to your eyes and your potential viewer and how you can capture something that will appeal to them. They will be looking at the photo on a computer screen or as a print and so you'll want to draw them in and through the complete frame of your shot, so think about getting down low. When you go low, you can add interest to your composition by including the floating log or the white pelican that is paddling by you at this very moment.

And consider if you want to have everything in focus. If you do, you'll want to stick with an aperture setting of f/8 or higher. But think about using f/4.5 and having the log in focus and Mount Moran and the distant shoreline a bit out of focus. This limited depth of field will make for a different shot that may end up being one of your favorites. The scene will still be instantly recognizable because almost everyone has seen a photo of Oxbow Bend, but they may never have seen it from the surface of the river.

And here's a radical idea. Don't shoot Mount Moran at all for a few of your frames. Point your camera at the shoreline just south of where you are now standing and you'll likely have a beautiful mirror reflection of the evergreens in the Snake River.

It took me several visits to realize that focusing in on Mount Moran completely was causing me to miss the beauty that is all around Oxbow Bend. This is particularly true during the last week of September when the trees that line the western shoreline light up with the turning of their leaves. Leaving Mount Moran out of your composition allows you to show the viewer nature's seasonal beauty just as effectively.

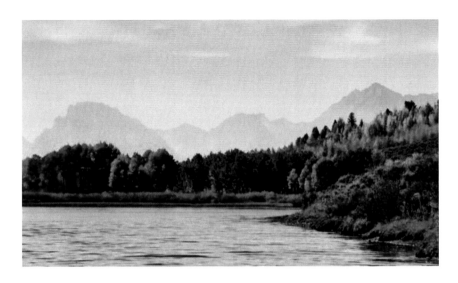

I would urge you to walk up and down the bank and try out lots of different compositions and angles. Working the scene may allow you to serendipitously "find" a shot that you didn't see initially and this happens often in a place like Oxbow. Experiment with different focal lengths and pull out your wide angle if you've got one. Zoom in on Mount Moran and check out how that view might look in one of your compositions. In essence, act like you did when you first got a camera and started to experiment with photography. Remember how you were shooting everything in sight? This would be a perfect place to recreate that approach.

Once you've filled up a memory card or two, I'd suggest you return to your car and drive about a quarter of a mile east and pull into the parking lot on your right. This is a different vantage point that is often overlooked by first time visitors and it allows you to see the scene from a completely different perspective. True, you do lose the magical reflection - but what you gain is a more sweeping vista that works very well as a landscape photo.

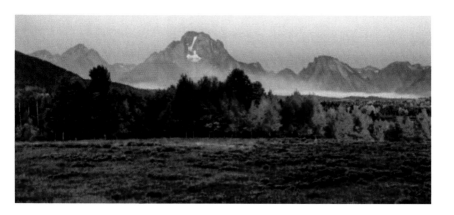

And since you are here early in the morning, there is a good chance that you will see the herd of elk that frequents the meadow directly south of this location. They should be grazing in the dawn hour and with a long zoom you should be able to get some decent shots with your lens and tripod.

You may also want to hike down to the left on the trees that are directly to the west of the parking lot because when you clear the trees you'll get another vista of the mountain range looking west/northwest that is equally impressive. And then if you've got enough energy, head across the parking lot and cross Highway 89 and climb about halfway up the hill in front of you for yet another stellar photo location site. This last position allows you to once again see the bend in the river and the panoramic view of the Mount Moran with the valley spread out for miles and miles. As you hike up the hillside with your equipment, you'll probably be saying "I sure hope this is worth it" - and it is, I assure you.

Although it will be hard to leave this magical place, you'll need to move on since you've still got good light this morning and you'll want to put it to good use. So hop in your car and head west as we trek over to Jackson Lake Lodge for some morning coffee and some absolutely stunning views.

Chapter Nine - Jackson Lake Lodge and Colter Bay

As you leave the parking lot near Oxbow Bend, there's another relatively unknown location that 98% of visitors miss during their trip to the park. Approximately one quarter of a mile west of the main Oxbow Bend parking lot is an unmarked dirt road on your left. This is known to locals as Cattleman's Bridge, although the bridge was torn down years ago by the Park Service. Turn left onto this road.

Except during heavy rains, this road is bumpy but you can drive a rental car on it all the way to the end. But what you'll want to do is drive very slowly because this is a very popular destination for moose, deer and elk. There are dense trees and meadows and about a quarter mile in you will come to a large meadow on your right. Pull over and you can get a different landscape shot of just Mount Moran as it rises majestically out of the west. There are a couple of large trees in the meadow and you can decide whether you would like to add them as a framing device or just have an open shot of the scene.

As you drive to the end of the road, you'll see that you've come to a spot that is popular with the locals for trout fishing and kayaking. There is a small parking area where you can get out and explore a bit on the level ground. Be sure and spend some time watching the Snake River to your south as often you can see river otters and white pelicans in the area.

Although you don't have a view of the Tetons from this point, you do get a chance to experience the quiet and solitude of the moment and you may luck out and get a decent wildlife shot while you're in the area.

Then you'll want to hop back in your vehicle and retrace your drive in until you rejoin the main highway. Turn left and proceed past the road on your left (which is Teton Park Road) and veer north. Approximately a half mile on your left after the junction, you'll see a parking lot. Pull into the lot and you'll get a grand view of the meadows below framed by aspen trees.

This area is also frequented by grizzlies in the spring as they prey on newborn elk, so be on the lookout and don't wander too far west in search of a perfect shot. In fact, the whole area around this meadow is prime bear country and you'll often see signs posted by the Park Service saying "no access beyond this point". I'd urge you to follow the advice of the Park Rangers who post these signs. I was standing in this same parking lot a couple of years ago in mid-morning when a lady drove into the lot and asked me if I had seen the grizzly. I looked at her quizzically and she pointed right across the road where a grizzly was moving up the hill there. To say I was surprised would be an understatement as I was so focused on setting up my landscape shot in front of me that I didn't look around.

But I've learned from that and I hope you will too. Even if your intent in to shoot landscape and nature shots only, remember that you're standing in an area that has the largest concentration of wildlife in North America. That's why I now travel with two camera bodies - each equipped with a different lens. On my full frame DSLR camera, I have a

relatively wide angle zoom lens that goes from 24mm to 70mm. On my other camera, which has the DX sensor - which is smaller - I have a long zoom lens that goes from 70mm to 300mm. And because it has the digital DX sensor, the equivalent range goes up to 450mm - which is usually effective for wildlife that is not too far away.

The view you see west from this lot - and the lot a quarter of a mile further north - is a grand panorama of the area known as Willow Flats. You also see the complete Teton mountain range with Jackson Lake at its base. You'll definitely want to pull out your tripod and do a series of shots from left to right so you can use your panorama software when you return home. And if you don't have a wide angle lens at this point, you'll need to figure out just how you'd like to frame up the shot.

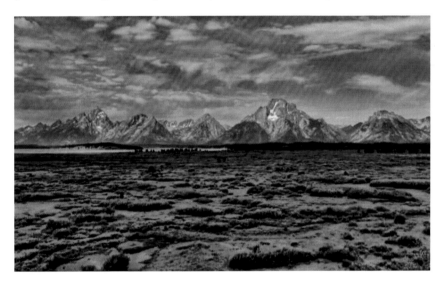

A slightly different - but similar - viewpoint awaits you when you visit Jackson Lake Lodge, so if you are pressed for time, you can avoid this stop and head on up to the lodge.

Assuming you do have some time, I'd suggest you take a series of shots - some wide and some with one particular focal point. I think the long zoom shot of Lake Jackson in the foreground with the peak of Grand Teton centered in the frame is effective as is the shot of Mount Moran zoomed in with just a part of Willow Flats within the frame.

Once you are happy with your work, then hop back in your car and head north about a half a mile. You'll cross a bridge just before you get to the Jackson Lake Lodge turn. You will want to scan the area left and right when you are on the bridge because often you can spot wildlife from this vantage point. If you do see wildlife present, you can pull over on the right immediately after the bridge as there is room for a car on that side.

But if you don't see any wildlife, just proceed north and you'll see the sign for the Lodge almost immediately. You will want to turn left and head west. Once you make the turn, on your left in about a quarter of a mile is another road that you can turn on if you need gasoline. There is a station there that also has bottled water, snacks and cold drinks.

But if your gas tank is still full, head west until the road dead ends. You can park anywhere you can find a spot as it is free parking. And then grab your gear and walk right in to the main doors of the Lodge for a visual treat that amazes most people.

As I was composing this book, I thought about inserting a photo here of the view you see when you walk up the main stairs of the lodge and enter the main room. It is spectacular - to say the least - and I decided that this is one of those places where a photo doesn't do the experience the justice it deserves. So, be ready to be surprised.

And here's a quick history lesson about this very spot in which you are now standing. This is the famous location that Yellowstone Park Superintendant Horace Albright brought the Rockefeller family back in the 1930s. At that time, this area was not a National Park and it was being taken over by commercial interests. He brought the family here and told them that this view was going to be lost to future generations forever and the government didn't have the means to do anything about it.

They enjoyed a picnic here and returned home. A few days later, Horace Albright received a telegram from Rockefeller. It said simply

"Buy it all". And the Rockefeller family did just that over the next decade and ultimately gifted the land to the public. The Lodge was owned by them for decades and serves as a reminder that Horace Albright and the Rockefeller family were visionaries that saved this magnificent area for all of us to enjoy.

In fact, the very spot where they had their picnic on that fateful day is up a steep hill to your right when you exit west from the main lobby of the Lodge. This is still known today as "Picnic Hill" and if you're a history buff, then you'll want to make the strenuous hike upwards to see what they saw exactly. But for the rest of the world who want to capture the view, the area directly behind the Lodge is magnificent. I'd urge you to shoot away and then after you've shot all that can be shot, I'd suggest that you sit down on one of the outside bar stools and have a soft drink or a cocktail. Then you can just gaze at the wide expanse of nature that I believe will fill your eyes with wonder.

If you're feeling adventurous, you can leave the large patio area and walk south to where the patio ends and you can explore the southern area that has both cabins and hotel accommodations. Although there are good views here as well, I personally think the best views are right from the patio area. And be sure and look closely at the meadows below you. Because of the abundance of willow trees, there are often one or more moose grazing below. Because it is such a large area, you'll need to look closely as the moose or elk or bear may just appear as a small dark figure amidst the greenery.

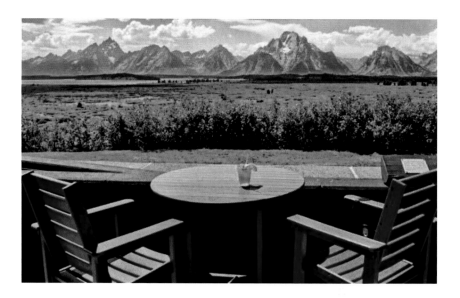

Before you leave, you'll want to consider grabbing an early lunch or sandwich at one of the two restaurants within the lodge. I personally am a big fan of the bison chili in the Mural Room - which also happens to have spectacular views from every table. And because you are in a National Park facility, the prices aren't too pricey. And don't forget to utilize the restrooms that are at the top on the stairs before you leave.

After you've had your relaxation moment, then you'll want to jump back into your vehicle and return to the main highway. When you reach the highway, you'll want to turn left and head north to Colter Bay. It is a bit of a drive - almost five miles - but the scenery is spectacular along the way and there are several turnouts that you'll no doubt want to pull out into for a shot or two.

When you reach the Colter Bay Junction, you'll want to turn left and head west. This area is named for John Colter, who left the Lewis and Clark expedition and is considered the first white explorer to discover this area - as well as Yellowstone to the north.

You are entering in to an area that is pretty populated during the summer months with visitors from all around the world. This is the largest concentration of cabins and tent sites within the park. If you

have some extra time on one of your afternoons, you might want to explore this area by driving the many short roads that head north and south through the woods.

But we are headed west until the parking lots end. You'll then want to turn right and drive north until that parking lot there also ends. Park somewhere in this vicinity and grab your gear and head down to the shoreline of Jackson Lake.

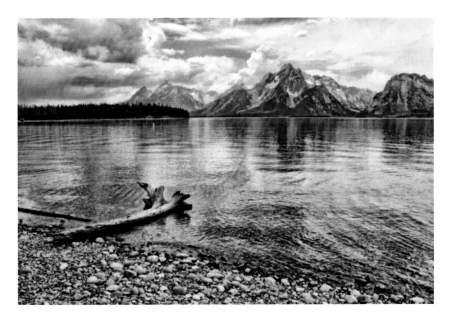

As you walk the shoreline, you will note that it is covered with millions of small rocks. Be sure and get down low with your tripod and use the rocks as foreground interest. And of course if there is a log or piece of driftwood present, then that would make a good foreground anchor that will help lead your viewer's eyes through the frame of the photo. Then they will see the magnificence of the Teton range that seems to arise directly from the waters of the lake and dominates the western bank.

Walk up and down the shoreline and experiment with wide and short angles and with large and small depth of field. This can be accomplished by using different aperture settings - from f/4.0 to f/22.

And because you may be here as the midday light begins to get harsh, I'd suggest you take some bracketed under and over exposed shots as well that you can blend when you get home.

Let's assume that the afternoon light is now upon you as you finish up at Colter Bay. You are a scant few miles from the southern entrance to Yellowstone and so if you want to take a quick side trip up to that park for an afternoon, this would be the closest place to do so. Otherwise, you'll want to head south and back to town or your campsite for a few hours . As you have done before you can get some rest before you head out again in the early evening for some more wildlife viewing.

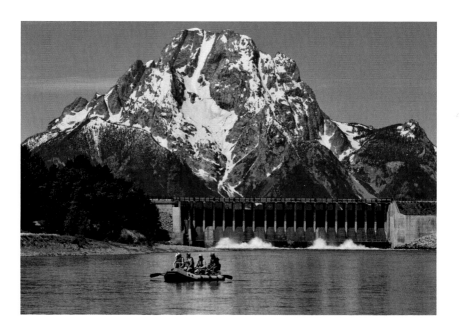

Chapter Ten - Morning at the Two Overlooks - Snake River and Blacktail Ponds

As you prepare to head out before dawn once again, be sure and consume an energy bar or two this morning since you've got a full morning of shooting ahead of you. Since by now you are an old hand at checking for today's sunrise time, I'd suggest you leave at least 45 minutes prior to sunrise. As in the past, this will give you time to set up your tripod properly and it allows a cushion in the event that you encounter wildlife on your journey to your next landscape location.

Heading north on Highway 89 out of downtown Jackson, you are going to travel approximately 20 miles to the location made famous by Ansel Adams - the Snake River Overlook. Almost everyone in North America has seen his iconic shot of the bending river below the ridge and his timeless interpretation of the scene.

When you arrive, you'll turn left off the highway and you'll notice a long parking lot with a turnaround at the end. If you are early enough, the lot may be deserted - but if you're late, you might scramble to find a spot. This is what I call I magnet location - it draws everyone on vacation who has a camera.

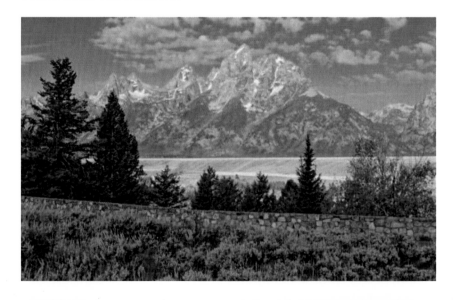

As you get out of your car and approach the overlook, you'll see a four feet stone wall that has been built out of native boulders and that extends for a hundred feet or more. You'll want to set up as far to the north as possible where you still have a clear view of the river below. And although the wall is there to keep the crowds from walking off the overlook and down the hillside, you can easily jump up on the wall and get on the other side if you think that's a better setup location.

One thing you will note almost immediately is that this is not the exact scene before you that you saw in Ansel Adam's outstanding photo. Well, that's absolutely true. The trees in front of you have grown in the last 50 years and they do block more of the scene than they did when Ansel Adams was standing with his tripod where you are right now.

But you can still get that great turn in the Snake River below as it shifts its course west from its southerly flow. And if you are here before sunrise and the weather cooperates, you should be able to get that famous alpenglow light that turns the mountain range a beautiful shade of pink and red when the first light illuminates the mountains.

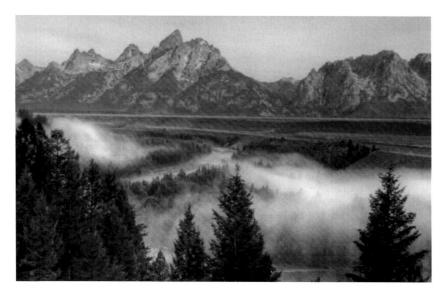

Many photographers feel that they can't get high enough to shoot over the trees like they would like - but it's the harsh reality of the location today. You can try standing on the wall and setting up your tripod on the wall itself, but that's pretty iffy as a stable platform.

Another thing to look and hope for when you visit this location is the early morning fog that will hang just above the river when it is cool in the morning. Now if you are visiting in the middle of summer, it may be too hot for this to occur for you. But if you are here in the early spring or late autumn time period, it is likely to happen. And so you'll obviously want to incorporate this nature phenomenon in your shot - hopefully where you can still see the river below peeking through the fog.

Because it will be very early when you visit, you'll be dealing with uneven light as the first light touches the mountains. I would suggest you crank up your ISO setting as far as possible without causing too much noise to appear. On most newer DSLR cameras, you can safely go to 1000 ISO and still retain good clarity. I would then set my aperture setting at f/8 (if cloud cover is extensive) or f/16 (if little cloud cover is present) and use your remote to trigger the shutter while your camera in on the tripod. In the early morning light, this may cause a relatively long exposure, but it will allow you to capture the nuances of color and light that appear at this magical site. And remember, if you don't have a remote trigger, just use the built in timer that virtually every camera made it the last ten years has available.

And if you happen to not have gotten up as early as you planned, or if you decided to have breakfast with the family before you headed out, don't despair. Although this is one of the four locations that I think merit a specific sunrise trip (Oxbow Bend, Moulton Barn and Triangle X Ranch are the others) - it doesn't mean you can't take good shot at any point in the morning. Because of the location, you can reasonably shoot here until at least noon, but you'll find that the afternoon sun and haze may make it untenable past that time.

You may also want to experiment with setting up your tripod a little bit south of the standard location where everyone sets up. You have to move left past the trees in the foreground and you'll come to another opening in the scene. You cannot capture the bend in the river as well, but it is still a fine shot and allows the depth that so many landscape photographers crave when shooting this type of photo.

One other thing you might want to consider is to drop back by here for a few brief minutes in mid-morning. The reason is that you can then use a circular polarizer or a warming filter much more effectively when you have good light. This will help you control the exposure and should result in a couple of images that you'll really like as a contrast to your early morning shots.

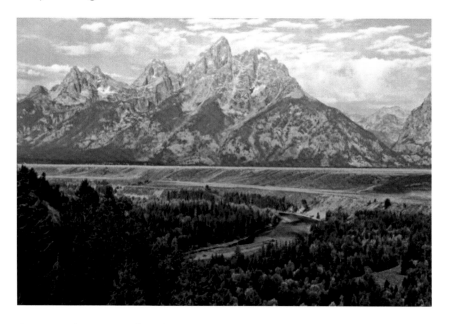

Once you have completed working the scene at the Snake River Overlook, I'd suggest you hop in your vehicle and head approximately seven miles south to our next stop - Blacktail Ponds Overlook.

You may feel like you are backtracking a bit - and you are - but I wanted to put you at the best spot first during the very early morning light. Because of its proximity, Blacktail Ponds Overlook is a great second

destination after the sun has risen high enough on the eastern horizon to illuminate the meadow below the mountain.

As you turn west off Highway 89 into the roadway that leads to the Blacktail Ponds parking lot, you'll notice that the ridge you are approaching is covered with sagebrush. Be sure and consider this as an appropriate foreground subject when you are composing your shots at this location. Although I'm the first to suggest a tripod when you are doing landscape photo work, I also think it's important to try getting low and seeing how this vantage point can change a composition. When I lead a photo tour and share this advice, invariably by the end of the tour half the group is laying on the ground and shooting landscapes and they often tell me that their favorites were the shots taken from the ground.

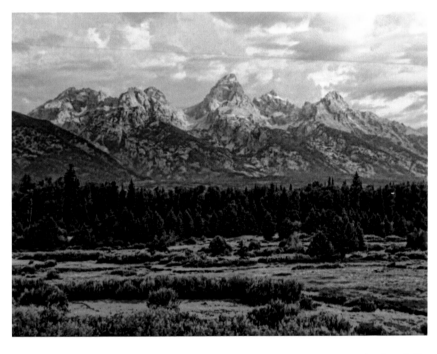

The meadow that lies below the ridge at Blacktail Ponds Overlook is full of willow trees and so you may happen upon a moose or two grazing below you. Most people spend all their time shooting off the ridge, but I find that if you are the adventurous type, you can get some killer shots by hiking down the ridge and shooting from the meadow itself. Because

of the way that the trees frame the bottom of the Teton mountain range, you can get some layers within the frame of your composition. And of course, it also is predicated on when you are visiting as the colors before you change as the season progresses and the hot sun turns the grasses from green to brown.

The scene before you at this overlook provides a multitude of different angles and composition options. There is of course the straight ahead shot with the meadow below. But after having visited this site many times, I've come to appreciate the subtle differences that you can make in your landscape photo work here by pivoting a bit from straight on and shooting in a west/southwest angle. You can accomplish this by walking to your right and head north for a hundred feet or so until you get a view of the small branch of the Snake River that is headed towards the mountains.

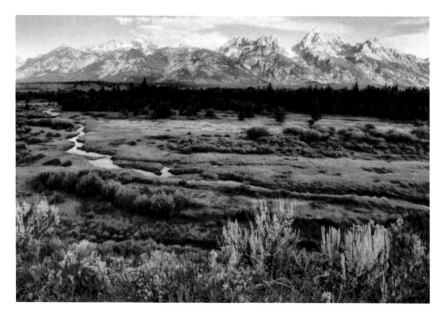

In terms of lens and camera setup, you've got lots and lots of options here as well. The cloud cover - or lack thereof - will help you determine what f/stop to go with and if the day is sunny, you'd be in good shape at f/16 as long as you are shooting from a tripod. I'd suggest a relatively

wide angle lens here to capture the expanse that lays below you, or you could rotate the tripod and capture a series of side by side shots to stitch together as a panorama later.

But what should you do if you've got extensive cloud cover when you visit Blacktail Ponds? Well, you can mark it as a place you'd like to return to on a different day, but if you are pressed for time then you'll have to make the best of a mediocre situation.

I'd suggest you put the cloud cover to good use by taking some darker exposures by going to manual exposure and overriding the "correct" exposure setting. You can experiment and see how the exposure will change the scene, but if you're willing to shoot several different exposures, I think you'll be amazed at how the clouds can become ominous and foreboding. I have found that always shooting on the "A" setting (Aperture Priority) is normally a good default but that there are many other options available that will depend specifically on the light and the scene.

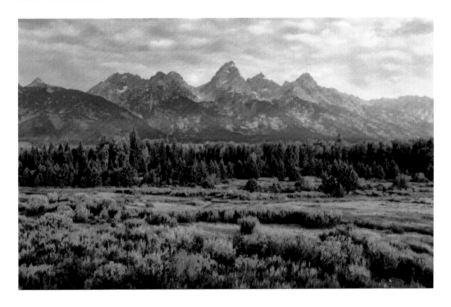

Another option is to experiment with filters if you have them with you. A polarizer or a warming filter can do wonders to change the scene into something different. There are also a lot of post processing filters on the market that will do this in the comfort of your own home if you didn't have a filter when you took the original shot.

After you have had a chance to work this scene, you'll probably notice that the sun is continuing its inevitable rise and the light and color nuances are changing. With that in mind, I'd suggest you pack up your gear and head back to Highway 89 and turn north for the next destination on our photography journey - Elk Ranch Flats.

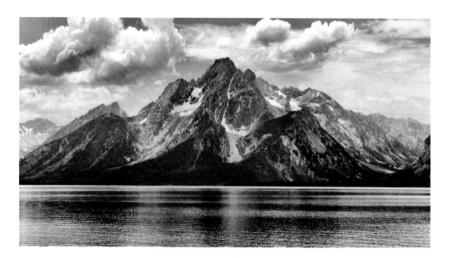

Chapter Eleven - Elk Ranch Flats and Buffalo Fork Ridge

As you head north once again on Highway 89, you'll be passing a lot of photo opportunities on your left and, as always, you'll want to keep your eyes peeled for wildlife. Normally mid morning is not prime wildlife viewing, but I've come across bears and moose at all times of the day. What is more likely is that you may encounter the bison herd that frequents the Jackson Hole valley that you are now driving through. And if they happen to be on the plains to your left with a shot of the Tetons as a backdrop, you'll certainly want to stop and set up a photo.

But your main objective for this drive is the turnoff at Elk Ranch Flats which is approximately 12 miles north of the Blacktail Ponds Overlook. And what we are in search of is that classic shot that you've seen a few dozen times of horses grazing in a large pasture with the Teton Range in the distance. Now if you have been lucky earlier in your visit, you've already gotten a similar shot on the inner Teton Park Road. But this shot is actually significantly different because of the different perspective - as well as the much longer distance that you are from the base of the mountains.

One of the unknown factors in this location is the presence of the horse herd. This is one of the locations that you will pass on the way to Oxbow Bend and Jackson Lake Lodge and so you may have an opportunity to see horses in the pasture when you least expect it. By itself, it is a classic panorama view of the Tetons spread as far as the eye can see. But with the horses, it takes on a wholly different look and feel and the old time wooden post fence adds to the appeal.

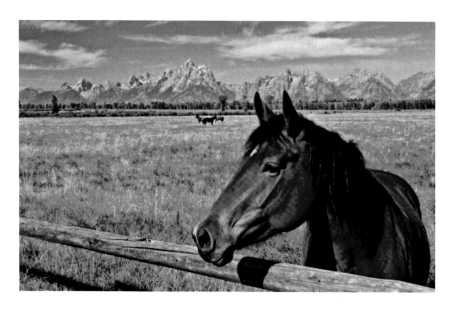

And that old wooden fence also has an added bonus of being a makeshift tripod if you just want to grab a quick shot on your way to another location. Another thing to be aware of is the fact that this location works equally well as a vertical or horizontal shot - sometimes referred to as portrait or landscape orientation. If you decide to shoot vertically with your camera on its side, you won't grab the panorama, but you will be able to create a sense of depth between the fence, the horses, the trees and the distant mountains.

I've only seen the horses come all the way to the fence a couple of times - they mostly keep their distance and stay together as a herd in the center of the pasture. But what you'll want to look for is a handful of horses that are doing something visually interesting - whether it be standing still in tandem or fighting each other with kicks and teeth baring. Horses do this all the time, but you have to watch for it and have a fast enough shutter speed to be able to capture the action in the split second in which it occurs. You may also want to single out one horse and use them as foreground interest even though it may be surrounded by a dozen other horses. And it is usually easiest to do this when you shoot vertically.

Okay, you may be reading this in the comfort of your favorite chair before you actually make your trip to Jackson Hole. I do the same whenever I visit a new location. But I hope you plan to take this book with you to the park as a shooting guide, or simply to trigger your decision of where you want to shoot if you are on a tight schedule. This is always particularly true if you are traveling with others who aren't really into photography.

I mention this here because the one thing that we've discussed previously that is out of anyone's control is the weather. The light may not be perfect, or you may be at this great pasture location in the evening instead of late morning - or there may simply be haze on the horizon because it is late afternoon. But instead of bemoaning your luck or lack of luck, I'd suggest you stop and look around and figure out what you can do with the conditions that present themselves to you. The fence isn't going away, nor is that great pasture in front of you and those mountains still are magnificent. Maybe it's time to get on your knees and shoot through the fence with the fence in detail at an aperture like f/4.5 and then the mountains will blur in the background. They will still be identifiable because of their unique nature and shape, but you'll have a shot that is different than almost anyone else.

You can also drive just a bit farther north from this location and you'll see a band of trees that are much closer to the road. This gives you the opportunity to use them to frame up a shot that works pretty well even in the harsh afternoon light.

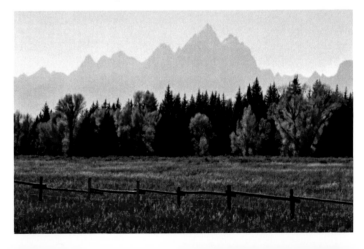

And another thing to watch for is the fact that the bison herd is well known for using the pastures on both sides of the road for grazing. Although the view to the east is not as spectacular, you can often get some good shots of the bison herd at this location. And if you have a longer zoom lens, you are likely to see antelope grazing in the eastern field alongside the bison and cattle that frequent Elk Ranch Flats.

There are also gaps in the wooden fences on both sides - this has been done to allow the wildlife to travel from one pasture to the other. If you are fortunate enough to come by here when the bison are relocating, be sure and set up your camera and tripod at the gap in the fence line. You'll have to look for these gaps, but they are definitely there and can end up helping you get a terrific shot of the herd going through them single file.

After you have finished working this location with your camera and lens, I'd suggest you load up your vehicle and continue north on Highway 89 to the Moran Junction. At this junction, you'll want to veer right and continue on Highway 26/287. As you begin to drive up a small hill just after the junction, you'll notice that the Buffalo Fork of the Snake River is paralleling the road. Be sure and keep a quick eye out on your right as often there are wildlife present near the banks of the river.

As you continue your climb, you'll see a dirt road that turns off the highway on your right at the crest of the ridge. You'll also notice that there is no sign here, but simply a dirt road that leads off into the distance. Turn on this dirt road and follow it and veer right when there is an opportunity to do so. You will find yourself on a plateau overlooking the Jackson Hole valley with a grove of aspen trees just below you.

Although this location doesn't show up on any maps that I've seen of the area, I've named it Buffalo Fork Ridge simply because of its location over the river. It is also another one of those spots that first timers to Grand Teton National Park seldom encounter because it is relatively unknown and unmarked. But it is the eastern boundary of the park and

you are welcome to drive to it and shoot panoramic shots to your heart's content.

I'd suggest using the widest angle lens in your bag and once again dragging out your tripod. You probably think I sound like a broken record, but I made the mistake of not using my tripod when I first visited this location and the photos turned out to be just a little soft. When you are doing panorama shooting, you'll want the crisp detail throughout the frame that an aperture setting of f/22 will give you. And you'll want to take into consideration the fact that there is so much real estate in front of you that you are not going to be able to capture it all with a single frame.

I'd personally take the first shot directly from where the ridge drops off the plateau and get as much of the aspens and Teton range in the frame as you can. I would also highly recommend that you take a series of shots from left to right for a panorama stitch when you return home. And you really ought to try the bracketing technique mentioned earlier - one at exposure, one at overexposure and one at underexposure - so that you can blend them together and bring out all the color that this scene presents you.

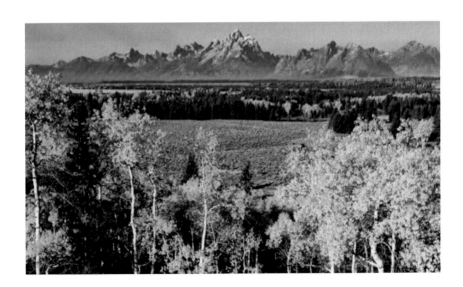

After shooting the straight on shot from a couple of different spots along the ridgeline, I'd urge you to walk towards the wooden fence line that is south of you. The fence allows you a different type of foreground interest if you get down low and shoot the fence as it trails off west and down the ridge. Try several different compositions to see what strikes your fancy, but remember that using both ends of the aperture spectrum, - let's say f/4.5 first and f/24 next - produces some strikingly different outcomes when shooting at the same location.

It really boils down to perspective and how much of the scene you want to have in focus. When I first visited the Tetons, I shot at the classic landscape settings of f/8 and f/16 - depending on whether I had sun or heavy clouds. But as I have progressed as a photographer, I've learned that having everything in perfect focus is not always the ideal technique. Sometimes that creamy blur that results from a setting like f/4.5 is actually better than absolute clarity throughout the image. This blur - that the Japanese named "bokeh" - is something you'll want to experiment with during your visit to Grand Teton National Park. Because there is little cost to compact flash or sd cards these days, you can experiment freely with these different aperture settings and discard them later if you decide you don't like the effect. But you may find that some of your favorites will incorporate bokeh as part of your overall visual presentation of what you saw during your visit.

If you are following this book's timeline, you'll find yourself on the Buffalo Fork Ridge as the morning light turns to noon light. I'd suggest you finish up with this location and return to the main highway and head back south/southwest for either a quick lunch at one of the park's lodges or a return to the town of Jackson for some afternoon rest and relaxation with your family or friends

Chapter Twelve - Final Thoughts

As we wind down our whirlwind photo visit to the Jackson Hole area, I hope you have enjoyed the journey as well as the images you've set up and produced. I've attempted here to describe the best times to visit the majority of Grand Teton National Park's best landscape and wildlife locations.

However, there are other locations that are worth exploring if you have more than four or five days in the area. Most visitors and photographers don't have the extra time and thus I've had to make some tough choices. And throughout this book, I've stayed away from recommending places that require a hike - since many photographers don't have the time nor the inclination to hike a long distance for one landscape shot. But I wanted to make you aware that there are two more hidden spots worth seeking out. They definitely require more effort - and time - before you can setup your tripod and shoot. But they are special shots that the dedicated landscape shooter might add to their shooting list when visiting Jackson Hole.

The first place is Heron Pond at the far north end of the park in Colter Bay. This requires an hour hike over relatively flat ground to get to the site, but the end result is a beautiful pond with more magical reflections of the Tetons on the pond's surface. You'll want to be sure you have a good day weather wise before you attempt this hike, as you'll need relatively clear skies and little wind to be sure your efforts pay off.

There is a well marked trail just off the south end of the most western parking lot at Colter Bay. This is the lot that ends at the edge of the lake when you drive in to Colter Bay from the main highway. You'll need to head west off HIghway 89 at the Colter Bay intersection and you'll come to the western lots. Then turn left (south) and park as close as you can to the end of the lot. Take some water with you and your tripod and follow the trail to Heron Pond. You can then set up along the shore of

the pond and get the reflection shot that eludes almost every visitor to Jackson Hole

There is another hidden location that requires a similar roundtrip hike of about an hour over a series of small hills. This is the path to Old Patriarch - a famous solitary pine that is a great foreground item for a wonderful panoramic shot of the Teton mountain range. To access this location, you'll want to drive south from the northern Jenny Lake junction approximately .6 miles and park on the side of the road. Then take your gear and hike directly east over a series of ridges. You'll ultimately come to a small gathering of trees and you'll be able to see the lone pine below you. The hike over should take you about 25 minutes and you'll want to set up east of the Old Patriarch so you can shoot the mountains behind the tree. I'd recommend a wide angle shot and also a series of zoom shots at different aperture settings - some with the tree in crisp detail and some with the mountains in focus and the tree less focused in the foreground.

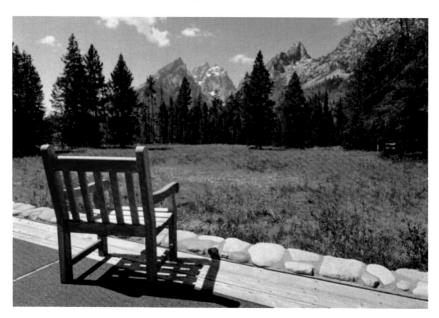

Some of my other favorite spots revolve around the Jenny Lake and it's lodge, so if you do decide to hike to Old Patriarch - be sure and also drive west at the northern junction and take some shots of the towering mountains from the porch of this rustic lodge in the woods. You can't miss it because the road west from the Jenny Lake northern junction will take you right by the front door.

And speaking of Jenny Lake, there are also some fine photo opportunities at the two lakes just north of Jenny Lake. String Lake and Leigh Lake are favorites for kayak and canoe trips and you can often catch these on the water at the foot of the mountains. They are both accessed by turning west off the Teton Park Road at the northern Jenny Lake Junction and veering right into their parking lots when the road splits just a half mile before you will encounter Jenny Lake Lodge.

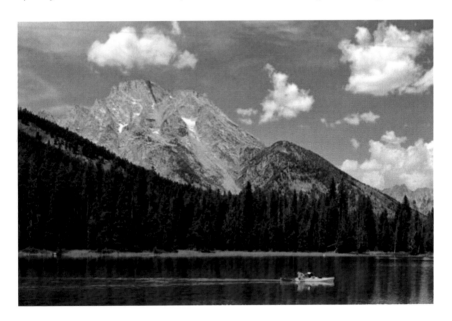

One of the dilemmas of these two lakes is that you are so close to the foot of the mountains that it is sometimes hard to get a wide enough angle to encompass the entire scene that you can see so clearly with your own eyes. But if you have extra time, it still is a lot of fun to try.

There is a pathway from the parking lot at String Lake headed north that will take you to the bank of Leigh Lake and there is a decent reflection shot available if the wind is cooperating when you visit.

Depending on the time of year of your visit, you may want to follow the shoreline of the lake south to get some shots with the reeds in the shallow water of the lake. You are most likely to see them when you encounter a small bridge crossing that veers slightly east from the shoreline. This is also an area that wildlife has been known to frequent, so once again be on the lookout for their presence.

As we've seen so often in our journey through the park together, there is beauty all around you that is worth a stop. Although I've spent little time describing the photo opportunities from Teton Park Road, it is not because they are not there - I just wanted to be sure that with limited time you didn't miss the truly must see locations. And it took me several visits to realize that I had to prioritize my stops in order to use the light and the time most effectively.

But if you are truly without a time limit crunch, then I'd highly recommend that you take a turn down any of the other dirt roads that you encounter on your visit. Some of them are dead ends and some of them are little visited. However, unless it is specifically marked as private, you can explore to your heart's content throughout the Jackson Hole area. That's how I discovered many of my favorite spots within Grand Teton Park and that's part of the wonder and joy of this magical national park.

I wanted to also invite you to visit my website - www.jeffclow.com - when you have a chance. I'm easy to reach via this site and I plan to always have a new tip or two to share with my friends. Since you've taken the time to read this book and accompany me on a written photo journey, I hope you'll consider me a friend as well.

In closing, I wish you good light and great skies on your visit to Grand Teton National Park. It has been a pleasure to share with you some of my favorite places in all of North America, and I'm looking forward to hearing from you if you discover a new spot that I can include in a future edition of this book.

Safe travels.